A–Z

OF

LETCHWORTH GARDEN CITY

PLACES – PEOPLE – HISTORY

Josh Tidy

AMBERLEY

This book is dedicated to my patient and understanding wife, Helen, who fortunately and (mostly!) uncomplainingly accepts the cherished place that Letchworth Garden City also holds in my affections.

All images © The Garden City Collection, Letchworth Garden City Heritage Foundation (www.gardencitycollection.com).

First published 2018

Amberley Publishing
The Hill, Stroud, Gloucestershire, GL5 4EP
www.amberley-books.com

Copyright © Josh Tidy, 2018

The right of Josh Tidy to be identified as the Author of this work has been asserted in accordance with the Copyrights, Designs and Patents Act 1988.

ISBN 978 1 4456 8662 2 (print)
ISBN 978 1 4456 8663 9 (ebook)

British Library Cataloguing in Publication Data. A catalogue record for this book is available from the British Library.

Origination by Amberley Publishing.
Printed in Great Britain.

Contents

Introduction

Welcome to this alphabetical exploration of Letchworth Garden City, which promises to look at this unique town's places, people and history. This book's alphabetical approach should hopefully make it one you can dip in and out of and reward revisiting, so you can return to it again and again.

The images and information contained within these pages are gleaned from a decade and a half working for Letchworth Garden City Heritage Foundation, the direct successor to the company that founded this unique town. The photographs, plans and ephemera reproduced within are from the Garden City Collection, the archive that documents and celebrates the rich history of the world's first garden city.

In the unusual approach to the subject matter, I have taken the opportunity not just to cover the 'greatest hits', so to speak, but also to highlight some of the lesser-known places, people and events that have all shaped Letchworth's fascinating history.

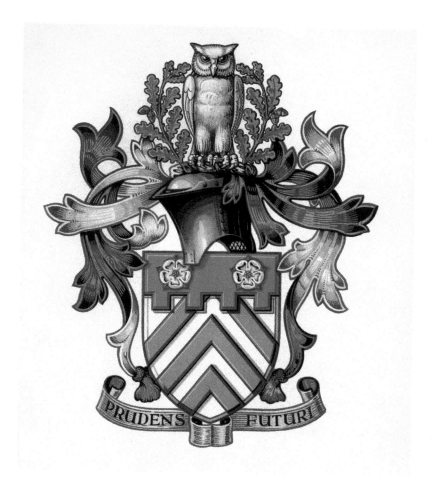

Adams, Thomas

Thomas Adams (1871–1940) was one of Letchworth Garden City's early 'heroes'. He was born on a dairy farm on the outskirts of Edinburgh. In 1893, as a farmer at Carlops near Penicuik, he took a very active interest in new local government arrangements, and he became a rural councillor there the following year, going on to give his support to the young Liberal hopeful Alexander Murray, Master of Elibank (1870–1920). Elibank won a parliamentary seat in 1900 and Adams followed him south to London.

In London, Adams secured a position as the first full-time secretary of the recently formed Garden Cities Association. The advertisement had called for a sympathetic acquaintance with Ebenezer Howard's 1898 book *To-morrow: A Peaceful Path to Real Reform*, and Adams apparently bought a copy at the station bookstall and read it en route from Edinburgh to London. He dedicated himself to his new role, and his hard work alongside the visionary Ebenezer Howard – gaining support from Fabians, Liberals and Conservatives alike – meant the association grew from strength to strength.

When the great social experiment finally found its practical application at Letchworth Garden City in 1903, Adams became the secretary of the company that built the town, First Garden City Ltd. He was an untiring publicist for Letchworth and the garden city movement, not least in the popular and successful 'Cheap Cottage Exhibition' in 1905.

Adams nonetheless left Letchworth for Wolverhampton in 1906, and for the next three years travelled around Britain as the first planning consultant to a variety of garden suburb proposals, which ultimately didn't happen, including plans for Knebworth with architect Sir Edwin Lutyens.

After the Housing and Town Planning Act of 1909 came into being, Adams briefed all parties on its drafting and then advised councils on the new Act – he was made the Board's Principal Planning Inspector. In 1913 he qualified as a surveyor and assisted with establishing the Town Planning Institute in 1914. He moved on to Canada in the summer of 1914 to advise its government commission on guiding the country's massive development. Adam then went on to America, where he assisted in founding the American City Planning Institute, and led a team to draw up the New York Regional Plan, published in 1929. In the 1930s Thomas Adams, alongside Raymond Unwin, was a key adviser to President Franklin D. Roosevelt's 'New Deal'.

Adams is rightly seen as one of the founders of town planning as a dedicated profession.

Thomas Adams, first secretary of the Garden Cities Association and of the First Garden City Ltd.

Anglia Match Company

The Anglia Match Company was formed by brothers Jacob and Julius (Jules) Gourary and Mr Gershonnen, who were Russian migrants who had a factory in Salzburg, Austria. They were Jewish and, having already escaped persecution in Russia, they moved the company to Letchworth Garden City amid the rise of Nazism in Europe.

Their Letchworth factory was opened on Works Road in January 1935 and staffed by workers from the recently closed Welwyn Match Co. Ltd. The name 'Anglia' was chosen so as to sound as English as possible.

In early days, the boxes were made in Salzburg, as were the splints, and the Letchworth factory labelled boxes, headed splints and packages. Gradually the whole operation moved to Letchworth. Originally, only Mr Gershonnen came over to become managing director of the new company, but as the threat of Anschluss (the absorption of Austria into Germany) beckoned the Salzburg factory was closed and many members of its staff came with the Gourary's to England.

One of these staff members was Mr Kahn, who settled in Letchworth Garden City with his family in the 1940s. Jules Gourary then made a permanent move to America and managed the company from afar. It is noted in 'A Striking Industry' that Rudolph Kahn worked under Mr Cohen, who had previously worked for the Welwyn Match Co. Ltd and was managing director by 1940. In 1951 Mr Cohen passed away suddenly on site and Kahn, who was district manager at the time, took over running of the company. He is said to have passed away soon after, leaving the company without a clear leader. The factory closed in 1953.

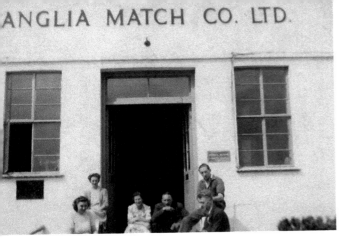

Employees pictured outside the Anglian Match Company factory.

Arbor Day

Arbor Day was invented in Nebraska, USA, by J. Sterling Morton in 1872 and many countries throughout the world continue to celebrate it today.

The first Arbor Day in Letchworth Garden City was celebrated on 29 February 1908 with the first tree planted by the guest visitor John Cockburn (former Premier of South Australia and founder of Australian Arbor Day) and the second tree by Ebenezer Howard.

In Letchworth the tree planting commenced with a procession led by children, often in costume, who would be given a certificate for planting their tree. The children would then sing 'The Planting Song' by Letchworth resident Harold Hare.

The little girl leading the first ever procession was described in a local newspaper as follows: 'a pretty child with a wreath of ivy, in which a single white flower has been set, her neck encircled by a chain of acorn cups'. That first Arbor Day was dogged by poor weather as expressed in the local paper, 'Under the lash of a bitter wind Letchworth was hugging the hills to keep itself warm' and the weather had evidently continued to be unkind every year, with the 1911 newspaper report referring to 'the inclement weather which appears to be an inevitable accompaniment of Arbor Day at Letchworth'. This local tradition, which populated Letchworth with many thousands of trees that still grace the Garden City today, continued until First World War in 1914.

Arbor Day in Letchworth in 1913. Ebenezer Howard is pictured in the centre of the photograph.

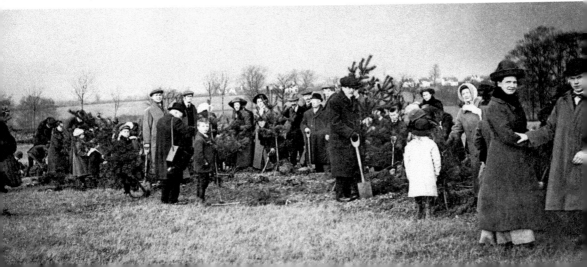

Arts & Crafts

The genesis and early development of Letchworth Garden City is intrinsically linked with the Arts and Crafts movement, which had developed over the second half of the nineteenth century, borne out of a rejection of modern mass industrialisation and a return towards traditional craftsmanship using simple forms, often using medieval, romantic or folk styles.

Its earliest proponents were the English artist and art critic John Ruskin (1819–1900) and the artist-craftsman William Morris (1834–96). Ruskin had examined the negative social impact of industrialisation, where it was creating poor living and working conditions. Morris began to put those ideas into practise, creating items with simplified designs, reflecting the skill of the craftsman. Many exponents of Arts and Crafts were socialists, seeking a more humane relationship between employer and employee.

Arts and Crafts influenced almost every aspect of art and design including architecture, painting, sculpture, graphics, illustration, book making, photography, domestic design and decorative arts (furniture, woodwork and stained glass).

The movement took its name from the Arts & Crafts Exhibition Society, which was formed in 1887, but it also encompassed a very wide range of like-minded societies and guilds, presenting a unified approach between architects, painters, sculptors and designers.

The Arts and Crafts movement shared many principles with Ebenezer Howard's ideas for 'Garden Cities', which are laid out in his 1898 book *To-Morrow: A Peaceful Path to Real Reform*. It found a fertile home in Letchworth itself, predominantly through the town's buildings and interiors, designed by architects and master planners Raymond Unwin and Barry Parker, along with their colleagues and contemporaries.

Letchworth also welcomed progressive industries attracted by the opportunity to build better factories within walking distance of good-quality houses with gardens for their workers. The town also had a talented community of craftsmen and artists, and many early residents embraced aspects of the simple life, from vegetarianism and rational dress to sleeping porches. Letchworth also led the revival of old traditions like May Day revels and folk dancing.

A typical Arts and Crafts interior design by Barry Parker.

Baillie Scott, Mackay Hugh

Mackay Hugh Baillie Scott was a prolific and renowned Arts and Crafts architect specialising in medieval hall houses. In 1906, he published *Houses and Gardens*, compiling his major works including Blackwell in Cumbria and Five Gables in Cambridge, both hugely influential designs, especially on Parker and Unwin.

He designed five major commissions in Letchworth Garden City between 1905 and 1908. Elmwood Cottages, at No. 7/7a Norton Way North, was designed as part of the

Tanglewood was designed by Baillie Scott in 1907.

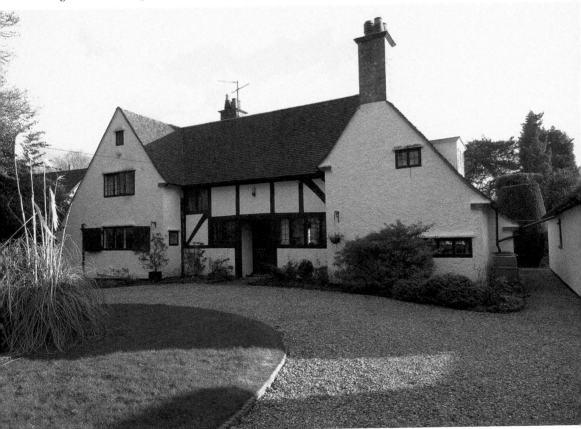

1905 Cheap Cottages Exhibition, along the medieval hall design where the central space is the focus of the house.

From its double 'M' gable at the centre, it incorporated one of Baillie Scott's favourite features: a striking downward sweep of the eaves to within a few feet of ground level to ensure the visual dominance of the roof (these have sadly been lost with modern extensions either side). Baillie-Scott wrote of Elmwood cottages, 'All buildings, even the smallest, have personalities – of sorts – and the cottage should have a soul of its own.' His other Letchworth commissions were Ingle Cottage on Norton Way North, Spring Wood on Spring Road, Tanglewood on Sollershott West and Corrie Wood on Hitchin Road.

They all share features characteristic of his style: large gables, timber framing, low sweeping rooflines and open-plan living areas, with fitted furniture and meticulous attention to small details such as door handles, latches and hinges.

Bartholomew, Edith Mary

Miss Bartholomew was a graduate and taught maths and Latin in London before moving to Letchworth Garden City with her family in 1908. When her mother died, she and her sister Frances moved to No. 154 Wilbury Road.

During the First World War she and Frances took charge of Letchworth Hospital's gardens, where they grew fruit and vegetables to help with the food shortage. She took an active part in the Guild of Help and was a keen Esperantist, as well as an accurate translator of Braille for the blind.

Frances was an active member of the Independent Labour Party and along with Mrs Steen and Mrs Gaunt was part of the first ever Letchworth Urban District Council in 1919. She died in March 1938, at the age of sixty-eight.

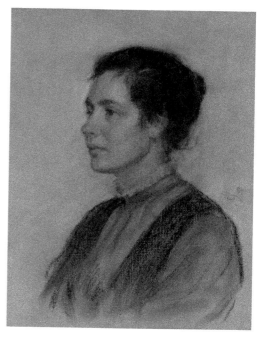

Pastel portrait by Sarah Birch of Edith Mary Bartholomew, *c.* 1910.

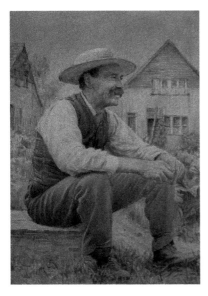

Oil on canvas portrait of George Bates by Frank S. Ogilvie.

Bates, George

Born in 1869 at Woburn, Buckinghamshire, he later moved to London and became involved in the Brotherhood Church and met Revd Bruce Wallace. Inspired by the garden city movement, he got a job with J. M. Dent & Sons Ltd, moving to Letchworth in 1907. He found the work to be too tiring and left to sell leadless glazed pottery at The Crockery on Leys Avenue. He was elected to the parish council and was a member of the Letchworth Trades and Labour Council and the Letchworth Gasmakers and General Labourer's Union.

When he died aged forty-six in January 1915, leaving no money for his mother and nephew, Letchworth Trades and Labour Council began a George Bates Memorial Fund. The money raised was used to clear the remaining mortgage on his house so his mother and nephew could live rent-free.

Belgians

Following the invasion of Belgium in August 1914 and the start of the First World War, thousands of refugees fled to Holland and Great Britain. The residents of Letchworth Garden City, anxious to help in some way, formed a committee in September 1914 to assist these refugees. Within weeks a party of thirty-seven refugees arrived. Many were still shaken from their ordeals and had nothing but the clothes on their back, but they were quickly found temporary lodgings, food, clothing, etc. Communication was difficult, conversing for the most part in broken French. One local Boy Scout, Frans Bogaert, who was born in Antwerp, was in great demand as an interpreter.

The newcomers were welcomed into the community. Older children attended Norton School and work was found for many of the men. Some people in the town thought that they were stealing jobs from Letchworth workers, but most people in

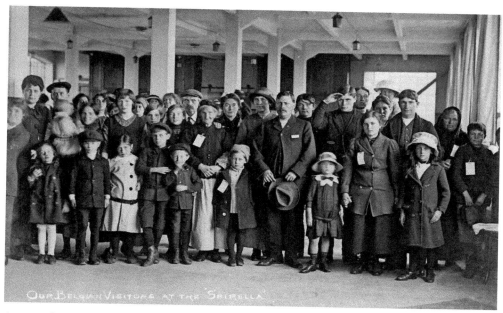

A postcard captioned 'Our Belgian Visitors at the "Spriella", 1914.

the town tried to make the visitors as welcome as possible. Many shopkeepers, keen to encourage more business, employed French-speaking staff and wrote menus and price lists in French.

Another Belgian refugee that fled to England was Jacques Kryn – reputedly with his pockets full of diamonds – along with his younger brother and his works manager Raoul Lahy. Early in 1915 the Kryn and Lahy metalworks built their factory on a 6-acre site in Dunhams Lane and more refugees came over to work there.

By August there were around 2,000 Belgians in Letchworth Garden City. To provide accommodation Hitchin Rural District Council applied to the local Government Board for a loan to build 100 houses. Twenty-six of these homes were to be built in Norton Road and Cashio Lane but local residents complained that it would devalue their property and therefore the council settled for the area around Campers Avenue and Spring Road, and this area soon became known as 'Little Belgium'.

When the First World War ended many of the Belgians returned to their homeland, but some stayed in Letchworth. In appreciation for all the help and support that they had received from the people of Letchworth the Belgians presented the town with a plaque and planted an oak tree in Howard Park, although unfortunately it died soon afterwards and had to be replaced.

Bennett & Bidwell

Robert Bennett (1878–1956) and (Benjamin) Wilson Bidwell (1877–1944) were two of Letchworth's most gifted and prolific architects. Both 'graduates' of Parker & Unwin's Buxton office, they came to Letchworth with them, assisting with the master plan and designing, between 1905 and 1939, many of the town's finest buildings.

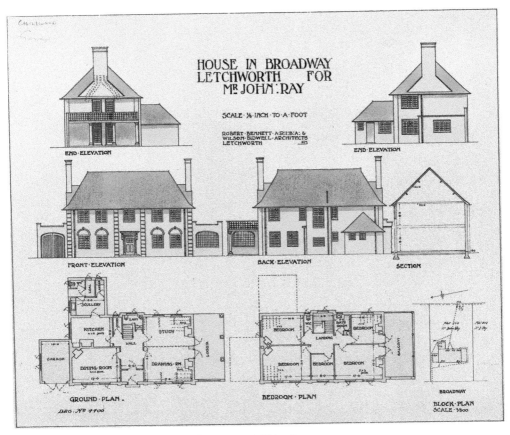

Plan for a house on Broadway designed by Bennett & Bidwell.

They designed several notable houses including the magnificent Carfax, on the corner of Broadway and Sollershott West, and No. 7 Willian Way, which they designed as the Bidwell's family home.

Perhaps their finest work was the Friends Meeting House at Howgills, which was both based on a historic Quaker building in the North (Briggflats) but also incorporated all the hallmarks of the classic 'Letchworth look'. They also designed three entries in the 1905 Cheap Cottages Exhibition, some of the best-quality groups within the numerous workers housing schemes and much of the town centre including shopping parades, the Town Hall and the grand art deco-style Broadway Cinema.

Black Squirrels

One noted local 'resident' is the black squirrel. The first wild black squirrel was spotted near Letchworth Garden City in 1912 and they have been spreading throughout the eastern counties ever since.

It was once thought that British black squirrels, which appear to be more aggressive than the greys, were a mutant produced by two grey squirrels mating. However,

A black squirrel, photographed in the garden at The International Garden Cities Exhibition.

scientists looking at the growing population have now found that the black squirrels are in fact an introduced subgroup that escaped from a menagerie over 100 years ago, their DNA being exactly the same as black squirrels found in the USA. It is believed that original squirrel would have been bought over by a wealthy Victorian landowner following the trend of introducing new species to the UK, possibly the Duke of Bedford at Woburn in Bedfordshire. Grey squirrels were themselves introduced to the UK by the Victorians and have now almost wiped out the native red squirrel population in the UK.

The latest estimates show there could be as many as 25,000 black squirrels in the east of England. Around Letchworth they already outnumber greys and could be dominant throughout the south and east of England in the next few decades.

Booth, Edith

Miss Edith Booth was greatly involved in education during the early years of the Garden City. She taught at the first elementary school ('The School in the Sheds', on Nevells Road) and when that closed in 1907 she moved to Norton Road School. Here she taught the infants, before later opening a private school at her house on Eastholm.

Miss Booth sitting in the garden of her house (and school) on Eastholm Green in 1910.

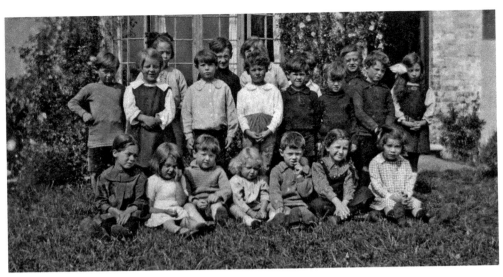

Children at Miss Booth's school on Eastholm Green.

One Letchworth resident recalls, 'Dear Miss Booth she always wore folk-weave dresses. Of course, they could have been woven in Letchworth – we had a silk weaving factory. She also used to wear beads which came right down to the bottom of her dress'.

She was active in the social life of Letchworth Garden City. As well as taking part in tree planting and other pageants, she also attended Labour Party meetings and supported the League of Nations Union, the Adult School Movement and Women's Suffrage.

Following her death in 1927 a committee was formed to decide on an appropriate memorial to her. A drinking fountain near to the common was decided upon but was unfortunately never built.

Broadway Cinema

The Broadway Cinema was designed by Letchworth architects Bennett & Bidwell in an attractive art deco style and built by Howard Hurst in red brick and concrete, which was cast on-site. The massive expanse of brickwork – the building required some 350,000 bricks – was broken by patterned concrete blocks framing the intricate traceried windows. Externally it was lit by huge red and blue neon lights.

The cinema was opened on 26 August 1936 with a black-tie gala performance of *Follow the Fleet* starring Ginger Rogers and Fred Astaire. The choice of films not only brought a bit of Hollywood glamour to the Garden City but also demonstrated the auditorium's near-perfect acoustics.

Over 1,400 people crammed in on that opening night, with many more left queuing outside, and they would have been dazzled by more than just Fred and Ginger's dancing!

The décor, designed by a specialist cinema interior designer, was finished in a stunning peacock and gold colour scheme, which was complemented by the smart matching uniforms of the ushers. Further glittering style was achieved by nearly 200 lights in the ceiling and concealed lamps on every other seat. There was an octagonal

foyer with free cloakrooms and an astonishing ventilation system, which drew in purified and temperature-controlled air from outside. In these innovations the Broadway outshone even some new London cinemas.

During the Second World War, the Broadway Cinema acted as a reception centre for an influx of evacuees and was even used as a synagogue for Letchworth's wartime Jewish population.

In 1955, both the Broadway and the Palace were refurbished to show the new widescreen CinemaScope films. To celebrate the installation of the new curvilinear screen, a gala reopening was held on 12 September, with a very respectably dressed audience watching the equally elegant Fred Astaire and Leslie Caron in *Daddy Long Legs*.

The Broadway remained popular throughout the following years, and also hosted occasional rallies and speeches, as well as becoming a venue for live music from the likes of Acker Bilk and Marti Wilde. Rumour has it, perhaps erroneously, that The Beatles were scheduled to play at the Broadway but cancelled when they hit the big time!

The cinema weathered the decline in attendance that resulted in the demise of so many of its contemporaries, including the Palace. Having survived thus far however, by 1995 the Broadway was in need of some attention and underwent a comprehensive refurbishment funded by the newly established Letchworth Garden City Heritage Foundation. This refurbishment brought the age of the multiplex to the town, creating twin screens downstairs in the stalls and upstairs retaining the sweep of the former circle in the grand screen one. The cinema temporarily closed to a performance of the 1936 film *Windbag the Sailor*.

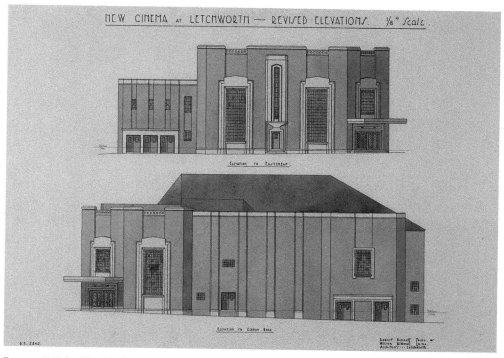

Bennett & Bidwell's plan for Broadway Cinema, which was designed and built in 1936.

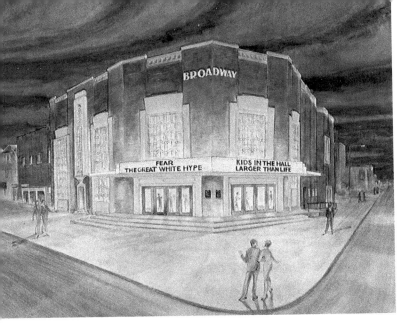

An artist's impression
of the new refurbished
Broadway Cinema in 1996.

Now, over eight decades after it opened, the cinema is thriving, with a new small auditorium known as screen four (opening in the former restaurant), the introduction of digital projection and popular live streaming of ballet and opera, and a recent multimillion-pound conversion to a theatre to accommodate live performances again.

Broadway Gardens

Town Square was originally planned to be the grand centre of Letchworth and house its civic buildings. However, it was not developed in the early years of the town's existence, and indeed was still being ploughed for wheat until after the First World War.

When a delegation from the RIBA Town Planning Conference in 1910 had criticised Letchworth for its lack of civic design, architects Parker and Unwin announced a series of public buildings to be built to commemorate the tenth anniversary of the Garden City (in 1913). In addition they drew up a plan for the proposed 'Central Square'.

Unfortunately the designs never progressed beyond a perspective drawing showing their designs, which were 'freely adapted from the works of Wren and other Masters'. The concept included grand formal buildings with a soaring spire dominating the scheme. The plans were not universally popular, but in any case the First World War postponed any building on the square, save for the planting of Lombardy poplars in the rough layout of the buildings.

Development around the Town Square continued piecemeal after the war with the museum, grammar school and council offices being built in a much less grand, more Georgian style between 1920 and the 1930s.

After being granted money from the Heritage Lottery Fund, the North Herts District Council proposed a dramatic redesign of the gardens to commemorate the town's centenary in 2003. The town square, having been called John F. Kennedy Gardens since 1963, was renamed Broadway Gardens. A plaque in the centre of the new paved area commemorates Parker and Unwin's 1912 plans for the square, appropriately as the space can now accommodate large gatherings as they had intended.

Church of St Hugh of Lincoln

The Church of St Hugh of Lincoln was initially founded in 1908, but the first Catholic services were held in the home of Bernard Newdigate, Astley Cottage in Baldock Road. Newdigate was the manager of The Arden Press, a company whose printing works moved to Letchworth in 1906.

The arrival in the fledgling garden city of this largely Catholic workforce led to the appointment of a missionary rector to the parish, Fr Adrian Fortescue, in 1907. Fr Fortescue's first task was to set up a temporary church, but in the meantime held his first mass on 30 November 1907 in 'The Sheds', temporary buildings near the railway station,

A new church was built largely with his own money, as was the presbytery and the land upon which they were built, along with many of the church furnishings. The church was designed by Sir Charles Spooner RIBA and built in 1908.

A Latin inscription carved in exquisite capitals ran along three of the inside walls of the church just below the ceiling, based on Soloman's prayer, 'Whosoever shall pray in this place, hear Thou from Thy dwelling place, that is, from heaven, and shew mercy.'

Fr Fortescue's great ambition had been to build a permanent church, for which he had drawn up his own plans, but this hope was thwarted by his untimely death in 1923 aged just forty-nine. An appeal to raise funds to build a new church was carried out in the 1930s, under the Priesthood of Fr J. L. Dove (the fundraising efforts including lectures at St Francis' College by G. K. Chesterton and Hillaire Belloc) and plans were drawn up in 1938 by Colonel John Dixon-Spain.

Work was set to begin on 4 September 1939, but the outbreak of the Second World War the day before meant that the plans had to be put on hold and the new church would not be built until long after the end of hostilities.

It was finally built in 1963 to almost exactly the same plans that had been approved twenty-four years earlier, with the building supervised by Messrs Woolhouse and Crampton from Nicholas & Dixon-Spain (the offices of its original architect, the late Colonel John Dixon-Spain).

On a visit in May 1965, the head of the Catholic Church of England, Cardinal John Carmel Heenan, said, 'Your church is one of the finest and most modern of the churches I have ever seen. It has the dignity of a cathedral.'

The church was modernised with interior decoration, a new roof and a new heating system in its silver jubilee year in 1988, and underwent another significant modernisation and redecoration in 2008, the parish's centenary year.

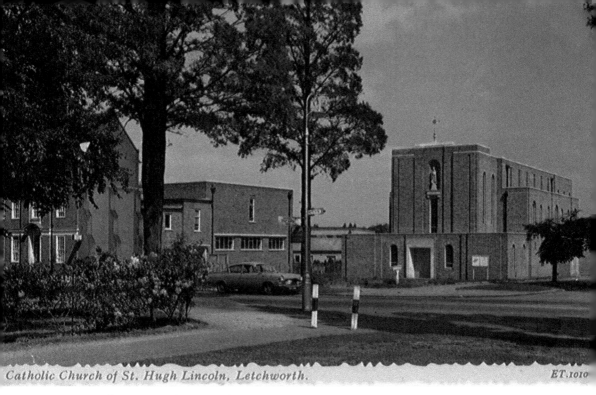

Catholic Church of St. Hugh Lincoln, Letchworth. ET.1010

A postcard of the Church of St Hugh of Lincoln in the late 1960s.

Cloisters

The Cloisters was commissioned by Annie Lawrence, a famous Letchworth character, who was enthusiastic, eccentric and unfortunately quite deaf by middle age. Consequently she is best remembered clutching her ear trumpet.

Through her social work she witnessed the unhealthiness and poverty of the London slums. Determined to resolve the problem, she conceived the idea of constructing a building where people could learn in the fresh air and among the beauty and harmony of nature.

Her vision, The Cloisters, would exist to promote open-air living. The new garden city was an obvious choice for such a venture. In 1905 she leased a 3-acre plot of land in Letchworth on which a magnificent and unique building, The Cloisters, was designed by W. H. Cowlishaw. Just two years later the first summer school took place. These schools were a great feature of early Garden City life. Many influential artists and reformers from all over the country visited The Cloisters.

A stay at The Cloisters was rather nonconformist, as summed up by David Garnett, Cowlishaw's nephew:

> One slept in a canvas cot sleeping a couple of feet off the floor, sheltered from rain or snow but in the open. In the morning one hauled up one's bed, either had a hot bath or a plunge in the swimming pool, collected a breakfast, which was eaten sitting raised up behind a vast slab of rose-coloured alabaster...Those breakfasting at the table looked like a painting of the last supper.

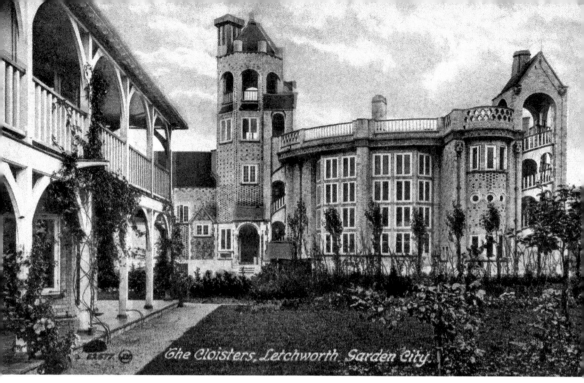

The Cloisters in a colourised postcard from *c.* 1912.

As well as summer schools there were musical and dramatic performances, and Sunday concerts became part of the weekly routine for a large majority of the town. Craft classes were also popular ranging from sandal making to housewifery. Miss Lawrence was also an ardent believer in the benefits of swimming and for many years awarded a fountain pen for children in the town who learnt to swim in her pool.

During the Second World War it was commandeered by the army, and the building became badly damaged. It was never returned to its previous use and was offered to the local Masonic fraternity by Lawrence, who accepted it in 1948. It is still in their care, and is also now a venue for weddings and events.

Coat of Arms

The term coat of arms was derived from the English noble practice of embroidering the family design on the surcoat, a garment that was worn over the armour or shirt of mail during battle.

In February 1945, Mr Leslie W Bennett, chairman of Letchworth Urban District Council presented the coat of arms for Letchworth Garden City to Mr W. D. Joslin, vice-chairman of Letchworth Urban District Council, who received it on behalf of the town.

The coat of arms was prepared and granted to Letchworth Garden City by the College of Heralds. In the grant of arms, the following description is given:

> The Arms following, that is to say, Argent three chevronels gules over all on a chief embattled azure two roses of the first barbed and seeded proper. And for the Crest on a Wreath of the colours an owl affrontee argent between two sprigs of oak vert fructed or.

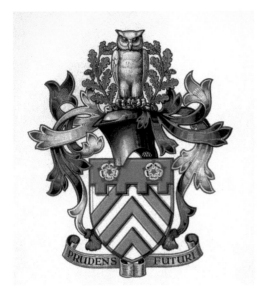

Letchworth Garden City's coat of arms.

In summary, the arms represent the building of the Garden City upon the foundations of the old Manor of Letchworth.

The shield is a combination of the arms of Barrington and Montfichett, who were Lords of the Manor of Letchworth in the fifteenth and sixteenth centuries. These are represented by the red chevrons on the silver ground.

The chief, which is the band in blue, typifies the city, as well as the blue sky and sun that are symbolic of the good air and living conditions associated with Letchworth. The two silver roses illustrate the garden. Taken together they are representative of the Garden City.

The helmet and wreath are conventional heraldic emblems.

The crest signifies the firm foundations upon which the Letchworth Garden City is planned, and this is reflected by the oak sprigs in the support of the crest.

The owl, the bird of wisdom, exemplifies the motto 'Thoughtful for the Future' ('*Prudens Futuri*').

The motto was considered to provide a reminder of the wisdom of Letchworth Garden City's founder Sir Ebenezer Howard, and at the same time was intended to provide a challenge to the citizens of Letchworth Garden City.

Conscientious Objectors

Men refusing to fight during the First World War often required as much bravery as the soldiers who served in the trenches. In 1916, with the numbers of volunteers for the army dwindling, conscription was introduced, which forced young able-bodied men to sign up to the armed forces.

There were a multitude of reasons for conscientious objection: religious grounds, morality issues, personal circumstances and family life, all of which were heard by county-based tribunals and judged on a regular basis within the British legal system. The outcome of these actions was often forced labour or imprisonment.

Whatever their reason for objecting, even though they were not out on the front line, 'Conchies' certainly didn't have it easy. Many were ridiculed in the streets, handed white feathers as a sign of cowardice, shunned by neighbours who they had known for years and ostracised from local communities. Hertfordshire provides a fascinating insight into many of the complex issues associated with conscientious objection. For example, while conscientious objectors came from across the county, there were particularly high numbers from Hitchin district, which had the highest rate of conscientious objection in the entire country. This was due in part to its strong Quaker and socialist links, and from the melting pot of socialist, radical liberal and independent-thinking residents in Letchworth Garden City.

The men and women who lived here were often in the papers for holding anti-war demonstrations and the conscientious objectors at Letchworth made local and national newspapers for their protests. Sixteen Letchworth men were imprisoned during the course of the war for not obeying military authority and carrying out their work in protest. One of Letchworth's conscientious objectors was Herbert Morrison, who would later become a Member of Parliament (serving as Home Secretary) and leader of the London Country Council.

In November 1916, six 'Conchies' were arrested on Letchworth railway platform, supported by a crowd of supporters and friends and family while singing hymns. They were doing this as a means of peaceful protest against the war. The opinions of many of the local soldiers and officers of the objectors were changed by the meeting

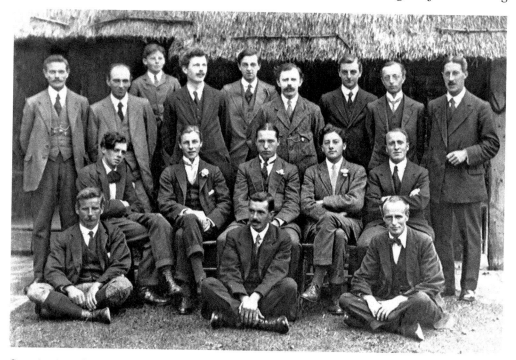

Conscientious objectors at Norton Farm in Letchworth Garden City.

and the arrest of the six ringleaders. One of the officers described his men as having 'not understood the position of the conscientious objector then [before the incident]; now they are very courteous' (*Mail* newspaper article, 23 November 1916).

An extract from a poem written by a conscientious objector at Norton Farm:

> In my cell so cold am I...
> Out go the lights, but sleep, though near,
> Comes not with all my writhing (rolling around trying to sleep);
> For of my home and loved ones dear
> I'm thinking, thinking, thinking.'

Cheap Cottages Exhibition, 1905

One of the most important events in the early history of Letchworth was the 1905 Cheap Cottages Exhibition. It's worth noting that the word 'cheap' didn't have the negative connotation then that it does now – some cottages were described in glowing terms as 'a marvel of cheapness'!

The exhibition came about because strict planning regulations meant that in rural areas the cost of building a cottage would be more than the tenant could afford to pay in rent. Mr J. St Loe Strachey, editor of *The Spectator* newspaper, put forth a proposal that an exhibition of '£150 cottages' should be held, which could demonstrate what economies could be achieved utilising new materials and methods. This challenge was eagerly taken up by First Garden City Ltd because, at the new town of Letchworth, rural byelaws would not be applicable.

A Frank Dean postcard of the 1905 Cheap Cottages Exhibition.

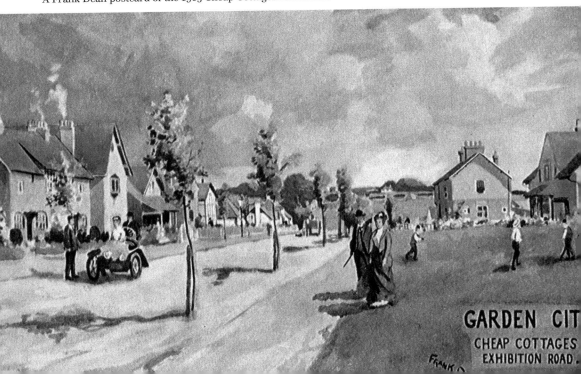

GARDEN CIT
CHEAP COTTAGES
EXHIBITION ROAD.

Over 125 cottages of all different shapes and sizes were built in Letchworth using either new and innovative materials and methods like concrete and cement or prefabrication, or traditional techniques like wooden boarding. They were concentrated largely around Icknield Way, Cross Street, The Quadrant, Wilbury Way and Nevells Road, then called Exhibition Road.

The exhibition was opened by the Duke of Devonshire, and acted as a publicity magnet to the fledgling garden city. Over 60,000 people visited the town between July and September 1905. With reporters attending from every national and regional newspaper, Letchworth became a household name. The exhibition persuaded the railway to build a (temporary) station to accommodate the throng, and so Letchworth was literally put on the map.

Most of the cottages survive, although most have now been significantly extended, and are celebrated locally by the Exhibition Cottages Group.

Cottage Exhibition, 1907

Following on from the success of the 1905 Cottages Exhibition, a further competition in Letchworth followed, The Urban Cottages & Smallholdings Exhibition, in 1907, with more of a focus on groups of houses rather than individual cottages.

The object of the exhibition was to:

Encourage Good Design and Economy in:
1. Workmen's Cottages, suitable for erection in towns and suburbs of large cities.
2. Cottages and Outbuildings suitable for Small Holdings.
3. Building materials, Implements, Fittings, and Furniture, suitable for the above classes.

Many entrants in the 1905 competition had found the £150 limit challenging so that was raised for the 1907 iteration. The competition attracted many more local architects, and many of the designs fit well into the existing 'Letchworth look' aesthetic.

The exhibition was opened on 19 July by the Marquis of Salisbury and finished on 30 September.

Fifty two houses were built in Gernon Road (then known as The Leys), Lytton Avenue (then known as Middle Street) and Pixmore Way. Six smallholdings were built on Baldock Road.

The *Municipal Journal*, on 22 November 1907 commented:

While the number of exhibits is much less than in the last Exhibition, the quality and general character is of a distinctly higher level.

There is a distinct improvement in the planning generally and in the attempts made to solve the problems in a sensible manner, though in nearly all the cottages the roofs are too much broken up with valleys and gables. We feel that the loss of wall-space and height in the bedrooms is not sufficiently compensated by the endeavour to make a picturesque exterior.

The 1907 exhibition was far less successful than its 1905 predecessor. By 1907 Letchworth Garden City was becoming established with a population of around 3,000 and a growing industrial base of factories arriving. There was also a less pressing

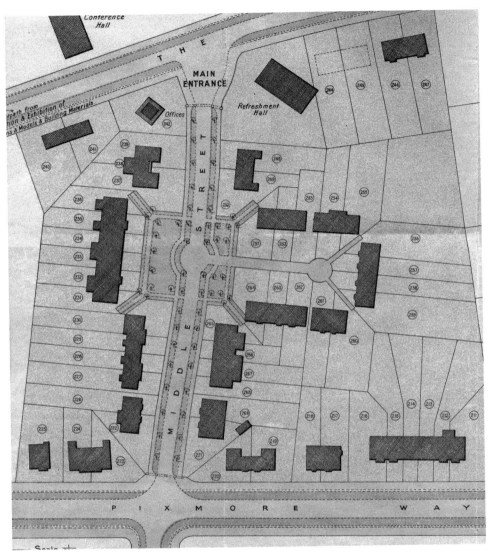

Plan of the 1907 Urban Cottages and Smallholdings Exhibition.

need to explore building materials and housing issues as there had been several other housing exhibitions throughout the country in the intervening two years. This may be the reason why only 4,000 people came to the exhibition and why press coverage was limited. It did, though, provide the town with some very handsomely designed homes.

Cranks

This cartoon by Louis Weirter was published in Letchworth's local newspaper, *The Citizen*, in 1909 and has frequently been used to illustrate Letchworth's alternative folk, affectionately referred to as 'Cranks', the use of which was popularised by George Orwell.

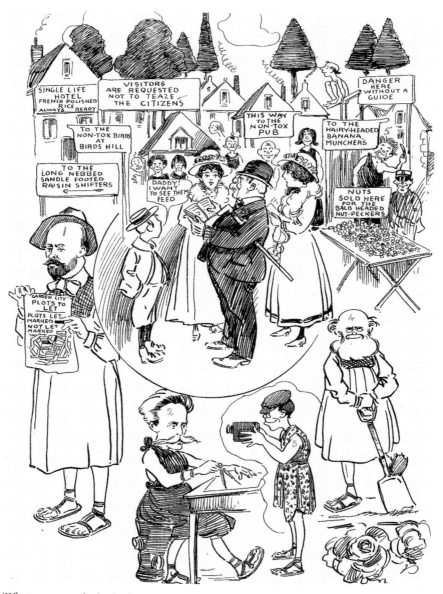

'What some people think of us' cartoon by Louis Weirter.

The cartoon shows visitors from London gawking at the 'Cranks'. Here, the alternative tendencies of some of Letchworth's most prominent citizens are mocked. The 'Un'winsome' architect in the foreground is Raymond Unwin, architect of Letchworth's town plan. He is photographed by Alfred Clutterbuck in a leopard skin and a flat 'Jaeger' woollen cap. To the right is First Garden City Ltd board member Howard Pearsall, digging his cabbage patch, and to the left Walter Gaunt, estate manager, hawks Garden City plots.

Courtenay M. Crickmer

Courtenay M. Cickmer (1879–1971) was one of Letchworth's finest architects, who had been so inspired by Ebenezer Howard and Thomas Adams when attending meetings of the Garden City Association in London that he moved to Letchworth himself in 1905. He never set up a practice in the town though; despite designing many Letchworth buildings, he still preferred to commute to his office at Lincolns Inn.

He designed many of the town's most beautiful private homes, such as Arana, Crossways and Loydons on Hitchin Road, and 'Deanrow' on Pasture Road. He also designed many distinguished groups of workers housing, such as on Rushby Walk, Ridge Road, Glebe Road and Ridge Avenue, as well as designing churches, school buildings, dairy stables and even the golf clubhouse.

His architectural style evolved throughout his long career and he embraced later styles even in his Letchworth commissions, designing the library in 1938 in an art deco style and leading the team in the design of the post-war Grange Estate.

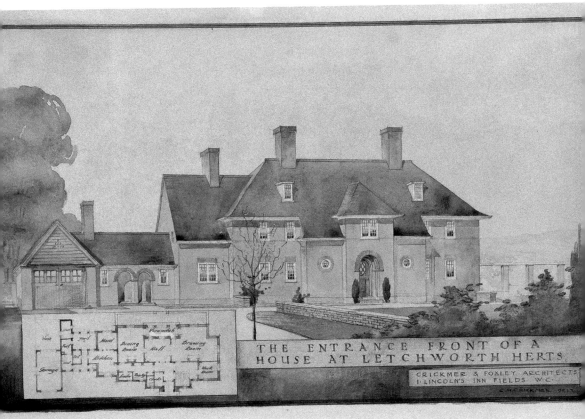

Watercolour sketch of a house in Letchworth designed by Crickmer and his assistant Allen Foxley.

D

Dents

J. M. Dent & Sons came to Letchworth from London in 1906. They also founded the Temple Press, mainly to produce the 'Everyman Library', a series of inexpensive literary classics.

Many workers moved from the Dent's factory in London to Letchworth Garden City. There were some complaints that Letchworth housing was too small for large families and so the company built Temple Gardens, off Green Lane, in 1907.

As well as a printing and binding shop the company had an engineering section that produced electric power to run the machines in the factory.

In 1953 they were renamed the Aldine Press – named after the fifteenth-century Italian printer Aldus Manutius, whom Joseph M. Dent greatly admired. Dent's was taken over by Weidenfeld and Nicholson in 1986.

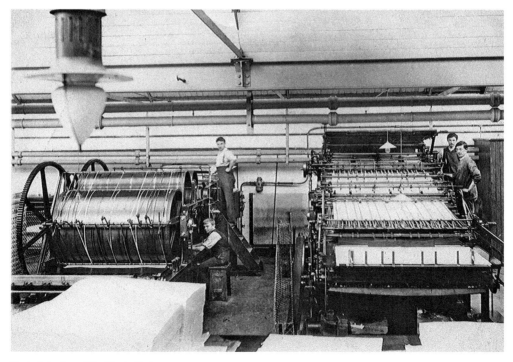

Early interior of the Dents factory, c. 1910.

Development Plans

One of the huge successes of Letchworth Garden City's development was the strength of the original master plan. However, Letchworth's early development was very piecemeal, First Garden City Ltd always waiting for the next industry or residents to come to the town before being able to invest further in infrastructure. The town still developed largely according to the original plan in part because the company produced development plans at regular intervals, which indicated the progress of the town's development.

A useful colour-coding system indicates that all completed houses and buildings are drawn in black and all roads that had been built are indicated in orange. Planned but as yet undeveloped roads are also included in white.

While much of the town developed exactly as planned, some road names are different: Souberie Avenue had previously been called Hanchett Road, or even Elbow Road, to reflect the bend in its layout. Several interesting features of the original masterplan were also not realised. Eastcheap was originally going to be mirrored by a symmetrical street, Westcheap, the other side of Broadway, but the town centre developed organically further to the east along Station Road and Les Avenue, and so Westcheap never happened.

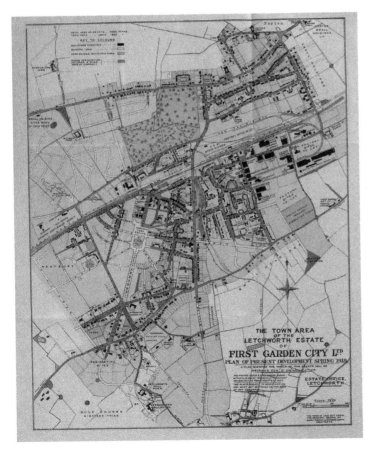

Letchworth Garden City Development Plan, 1918.

E

Esperanto

Esperanto, developed by Dr L. L. Zamenhof in 1887, was intended as a universal language. His aim was to create a language that would be easy for a majority of people to learn and understand, primarily due to its logical structure, and for there to be the opportunity to have unrestricted conversations worldwide.

Esperanto was adopted by Ebenezer Howard, founder of the garden city movement and Letchworth Garden City. The language appealed to his interest in ensuring international understanding between countries, which peaked at times of war.

Howard was president of the Esperanto Society in Letchworth from 1911 and a member of the wider-reaching Universal Esperanto Association, which still exists today. He also utilised the language to inform others of the garden city movement including the International Esperanto Congress meeting at Cambridge in 1907, where delegates were invited to visit Letchworth Garden City. Howard welcomed them with a speech in Esperanto, expressing his thoughts of their associated relationship: 'Esperanto and the Garden City are both bringing about new and better conditions of peace and agreement'.

There are additional records of Letchworth residents embracing the language including J. Leakey and C. W. Stanton, who were directors of Spirella. Eva L. Young, who had retired to Letchworth, wrote a number of songs in Esperanto with her composer brother Dalhousie.

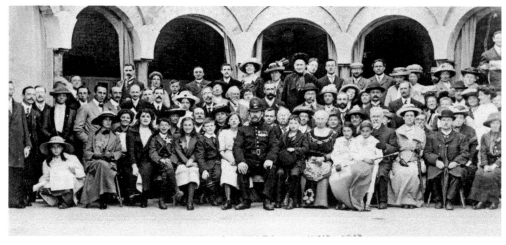

Esperantists, including Ebenezer Howard, at The Cloisters, 1913.

GVIDFOLIO TRA

◎ Letchworth (Ĝarden-urbo) ◎

Eldonita de la Letchworth Grupo Esperantista sub la aŭspicioj de U.E.A.

Regno : **ANGLUJO.** Provinco : **HERTFORDSHIRE.** Enlanda lingvo : **ANGLA.** Enlanda monunuo : 1 Funto (pound)=20ŝ.=10sm. 1 ŝilingo=12 pencoj=0.500. sm. Loĝantoj : 8,000.

Delegito—
SRO. F. A. GOODLIFFE, " Elm Tree House," Letchworth Lane. (ĉiutage).

Vicdelegito—
FINO F. M. BARTHOLOMEW, " Sunnyside," 13. Norton Way North.

Konsulino por Virinoj—
SINO A. M. BARTHOLOMEW, 13, Norton Way North.

Esperanta Grupo :
Prezidanto—
SRO. EBENEZER HOWARD (fondinto de la urbo), "Homesgarth," Sollershott.

Grupsekretarioj—
SRO. F. A. GOODLIFFE, " Elm Tree House " ; SRO. A. BRAYSHAW, 24, Broughton Hill.

Kursoj.—En Skittles Inn, 7.30-9.30, ĉiumerkrede, Oktobro ĝis Marto.

Hoteloj Rekomendataj.—Letchworth Hall Hotel : unuranga—Kuŝas en belaj ĉirkaŭaĵoj, litĉambro kaj matenmanĝo—3 sm. ĝis 3 sm. 750. Garden City Hotel.

Amuzajoj.—Koncertoj kaj publikaj paroladoj okazas tre ofte en la diversaj haloj : Howard Hall, Pixmore Hall, Co-operative Hall, kaj " The Skittles." Kinomatografejo sin trovas sur Eastcheap.

Banejo.—De la monato Junio, ĝis fino de Oktobro, la naĝbanejo apud Norton Way South estas malfermita de la sesa matene ĝis la sepa vespere, biletoj kostas tri pencojn.

Poŝtoficejoj.—La ĉefpoŝtoficejo staras apud la stacidomo sur Broadway. Ankaŭ estas du filioj, unu ĉe Norton Corner, alia ĉe Letchworth Lane Corner.

Komunikiloj.—Fiakroj kutime troviĝas ĉe la stacidomo je la alveno de la rapidaj vagonaroj, la prezo por veturi ĝis la hoteloj estas unu ŝilingo kaj ses pencoj.

Omnibuso iras kaj revenas de Norton ĝis Letchworth Lane poŝtoficejo por tri pencoj, ĉiuhore ĝis la oka vespere.

Aŭtomobilbuso iras kaj revenas de Luton ĝis Letchworth, trapasante Hitchin. La prezo ĝis la urbo Hitchin estas tri pencoj, ĝis Luton unu ŝilingo.

Booklet about Letchworth Garden City (in Esperanto, 'Garden-urbo') printed in 1913.

F

'Foursquare Our City', Letchworth's Banner

Letchworth Garden City's banner 'Four Square Our City' was designed by Edmund Hunter and woven at the St Edmundsbury Weaving Works in Letchworth. The banner was completed in time for the 1909 May Day celebrations and became a regular feature in many Letchworth processions, celebrations and events.

The title 'Four Square Our City' comes from a poem called 'The Building' by Henry Bryan Binns, which was published in the *City* magazine in January 1909.

The tree symbolises the town rooted in its foundation in 1903. Within the branches is a nest with eggs that reflects the promise of the future, and above is a golden star of hope. Behind the tree, corn and grass surround a faintly shown distant town of towers and pinnacles. This symbolises the goal of the endeavour, the 'beautiful city of our dream'. At the sides and top are scaffolding poles, a common sight in 1909 as the Garden City was being built. Laid against them are ladders leading upwards towards the completion of the town, towards knowledge and wisdom, and at the top are flaming torches leaning towards each other ready to be passed from hand to hand giving light and fire.

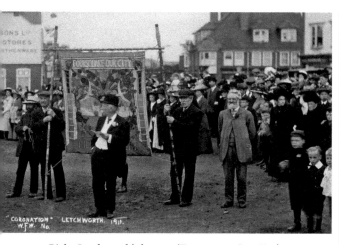

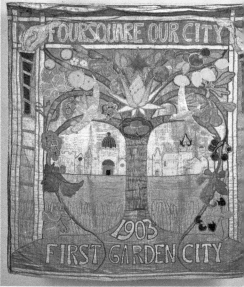

Right: Letchworth's banner 'Foursquare Our City'.

Above: Ebenezer Howard making a speech at the 1911 celebrations for the coronation of George V.

Garden City Greenway

The unique Garden City Greenway snakes in a 13.6-mile loop around the edge of the 5,500-acre Letchworth estate and through the beautiful countryside of the town's greenbelt.

The Greenway was opened in 2003. Its purpose is to enhance wildlife habitats and encourage diversity of flora and fauna while also improving public access to the countryside. Highlights include Willian Arboretum at Manor Wood, which brings together over thirty different tree varieties and the public amenities and children's play area at Radwell Meadows.

The Greenway is continually being enhanced and improved. Some successful additions have been the popular educational resource at Wymondley Wood (which includes three woodland trails and a number of interpretation boards which offer information on the natural environment), as well as two orchards near Manor Wood and Hillbrow car park, which were planted in 2008 to celebrate the centenary of the first Arbor Day.

Letchworth Garden City Greenway, 2003.

Gavin Jones

Colonel Gavin Jones was born in India in 1882 and served in the Indian Cavalry. Many generations of men in his family had been members of the Indian Army. Jones was known as 'Father of Cawnpore' because he was the architect of many of the civil and commercial buildings of that city in the 1880s. He retired from the regular army as a colonel after the First World War.

He took a great interest in the plants and geology of India and Afghanistan, and he pursued these interests between military duties. This led Jones to take up landscape gardening on his retirement from the army.

In 1923 he set up Gavin Jones' Nurseries and he arrived in Letchworth in 1925, leasing a field in Baldock Road and gradually developing it into extensive nurseries. Through the 1920s and 1930s Gavin Jones acquired a reputation for high-quality landscaping and undertook many large and prestigious projects in the notable houses and parklands around the Home Counties. Working in both the public and private sectors, Gavin Jones Landscape continued to expand its activities establishing an enviable reputation for undertaking every kind of landscaping project. Springtime was always devoted to the Chelsea Flower Show, where from 1926, Gavin Jones' Nurseries presented a large rock garden. These gardens won gold medals on numerous occasions.

For their exhibits, the colonel and his wife travelled abroad to the Alps, Morocco, Turkey and Greece to collect rare plants. A rare dwarf Scotch pine (believed to be unique) was discovered by Gavin Jones on Icknield Way and was subsequently named Pinus Icenii by Kew Gardens. Jones presented one of these Icenii plants to the Queen for the Windsor Castle gardens, one to Winston Churchill and one to Kew. At the Chelsea Flower show in 1951, 40 tons of Forest of Dean stone was used for the rock garden and one of the T. C. Jones cranes, made by K. and L., Letchworth, helped in the construction.

In later years, Sir Winston Churchill visited the flower shows at Chelsea and was impressed, ordering the Gavin Jones exhibit for Chartwell.

In 1956, A. M. Gavin Jones was elected president of Letchworth Rotary Club after previously acting as senior vice-president. His wife, Mrs Jones, was a local councillor. Gavin Jones died in 1967 after a brief illness, but Gavin Jones' Nurseries continued to operate and does to this day.

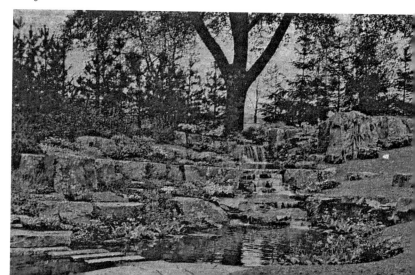

One of Gavin Jones' gold medal-winning gardens at the Chelsea Flower Show in 1963.

Geoffry Lucas, Thomas

Thomas Geoffry Lucas (1872–1947) was the only one of Letchworth's main architects to be based locally before the garden city was built here. He started practice in Hitchin in 1896, winning the prestigious commission of designing Hitchin Town Hall in 1899.

His proximity probably alerted him to the opportunity to enter the limited competition to design the master plan for the new garden city at Letchworth and he submitted an entry, with Sidney White Cranfield, in the limited competition. Although their entry failed (perhaps in part because of its uninspired square layout and grid system), nonetheless it introduced Lucas to First Garden City Ltd, who commissioned him to build the houses, known as Ploughmens Cottages, on Paddock Close. These were submitted into the 1905 Cheap Cottage Exhibition, as well as a pair of houses at Nos 118 and 120 Wilbury Road.

His other Letchworth work includes a number of fine houses on Norton Way North and Norton Way South, as well as some nostalgic country cottages on the (then) outskirts of the estate, on Croft Lane.

He never worked on any groups of housing in Letchworth, although he did design thirty-eight houses with Unwin at Hampstead, and worked with Unwin and Crickmer during the First World War on planning housing (essentially a new town) for the munitions workers at Gretna and Eastriggs.

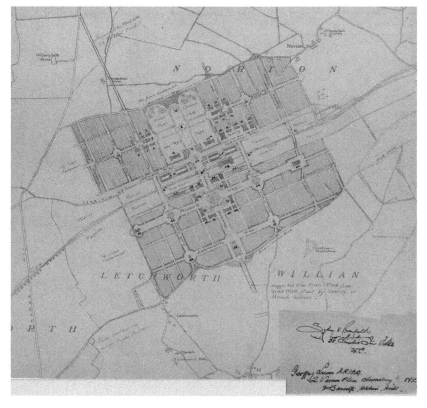

Geoffry Lucas' entry (with Sidney White Cranfield) for the master plan of Letchworth Garden City, 1903.

H

Hare, William Loftus

The son of Thomas Matthews Hare, William entered the engraving and printing business after his father's death. In 1899, he began managing the photo-engraving and collotype department of Bemrose, Derby and London, where he worked alongside his twin brother Harold Edward Hare (1869–1944).

His business career came to a close during the First World War when he became a lecturer on Theosophical Society for five years.

He was a member of the Society of Friends and worked for the Socialist Quaker Society as joint editor of their *Ploughshare* publication. Hare's brother Harold contributed several accompanying illustrations.

Between 1921 and 1936 he acted as editor for the Garden Cities and Town Planning Association. He was a strong advocate of garden city ideals. He died in March 1943 aged seventy-four.

William Loftus Hare portrait in oil by F. S. Ogilvie.

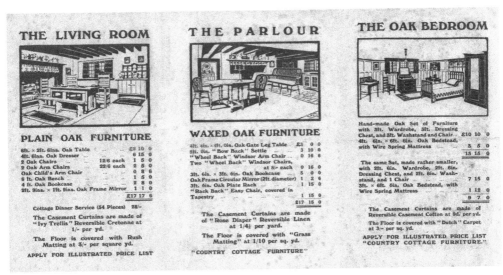

From a catalogue from the 1907 Cottage Exhibition in Letchworth, presenting the Letchworth range arranged by room.

Heals

The demand for well-made simple pieces of furniture in Letchworth Garden City (and later Hampstead Garden Suburb) inspired a London manufacturer of beds and mattresses, Heal & Son, to expand their remit and design their own range of furniture to cater to this style.

They started producing furniture that was well constructed and and of good quality, but as the design was simple, which meant that it was more affordable for the public, something manufacturers of the Arts and Crafts movement had found difficult to do.

Ambrose Heal designed a special Letchworth range and Heals used two houses in the 1905 Cheap Cottages Exhibition in Letchworth as showrooms to demonstrate the range, which was produced and sold between 1905 and the late 1930s.

The chair design in Heals' Letchworth range was modelled on the classic Arts and Crafts 'Clissett'-style chair with its ladder-back and rush seat, very much favoured by Parker and Unwin. Philip Clissett (1817–1913) was a Victorian chair maker whose designs were greatly influenced the Arts and Crafts movement. The popularity of the Clissett chair can be seen in its ubiquitous appearance in so many photographs of Letchworth house interiors.

Hignett, Cecil

Cecil Hignett (1879–1960) began his career working with the noted northern Arts and Crafts architect Edgar Wood in 1896 before joining Parker and Unwin in Buxton as assistant in 1900, becoming chief assistant upon moving with them to Letchworth in 1906. He was a meticulous draughtsman, working on the detailing and furnishing of Parker and Unwin's houses.

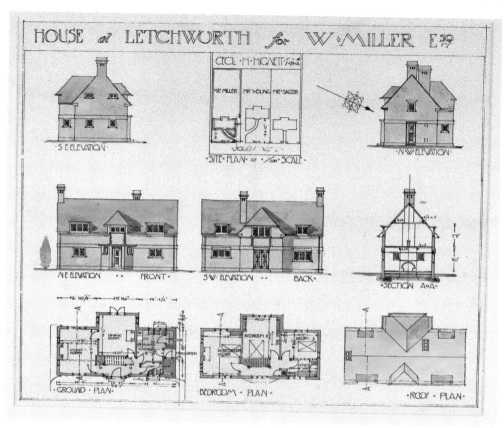

A house on South View, Letchworth, designed by Cecil Hignett.

His Letchworth work includes a huge range of different buildings and styles, from commercial buildings (like the parade of shops at Howard Park Corner, or The People's House on Station Road) and residential (both private houses and groups of workers cottages) to industrial (over half a dozen factories, perhaps the finest of which is the Spirella building built in 1912–20).

He had a love of both the traditional vernacular (as seen in his thatched buildings on Croft Lane) and modern design and materials (in his extensive factory designs).

Howard, Ebenezer

The founder of Letchworth Garden City and the garden city movement, Ebenezer Howard, wasn't a planner or an architect but a shorthand typist. Nonetheless, he was a visionary.

Ebenezer Howard was born in the City of London in 1850 to a modest middle-class family. After leaving school at fifteen and working in a number of offices as a shorthand clerk, he became a private secretary to Dr Joseph Parker, a well-known preacher.

At the age twenty-one he left for America and started a farm with friends in Howard County, Nebraska. Farming proved to be one of his less successful ventures and he moved to Chicago, taking up a job as a stenographer, where he stayed for four years.

An oil portrait of Ebenezer Howard by Gerald Spencer Pryse.

Chicago was a city experiencing rapid growth and terrible housing shortages. It was known for its formal landscaping where a large amount of parkland created 'a blend of town and country'.

On returning to London, he found the growing problems of poverty and poor living conditions, but also a growing movement trying to resolve these great issues. He took a job as a parliamentary reporter, which put him at the centre of all this activity, in which he remained for the rest of his working life. He became interested in social reform, absorbing practical and utopian ideas from his extensive reading and debating clubs. In 1898 he formulated his ideas, the results of decades of hard work and deep thinking, and published them in his masterpiece *To-Morrow: A Peaceful Path to Real Reform.*

Within just five years, the ideas expressed in this book had become a reality. Indeed, it is incredible to think that when Letchworth Garden City was founded in 1903, Ebenezer Howard had achieved his dream – his life's work – at the age of just fifty-three years old.

George Bernard Shaw claimed that Howard merited 'a Barony for the book, an Earldom for Letchworth and a Dukedom for Welwyn'.

In Letchworth, Howard played a full part in the social life of the garden city he helped create. He and his family rented a house on Norton Way South for a few years before moving into an apartment in Holmsgarth, a co-partnership development with communal facilities, in 1912. Although he moved to Welwyn, the second garden city, in 1920, when he died in 1928 he was buried here in Letchworth.

Howard Hall

The Grade II-listed building, the Mrs Howard Memorial Hall, was the first public building in Letchworth Garden City and quickly became its literary, music and social centre.

Built as a memorial to Ebenezer Howard's first wife, Elizabeth Ann Bills, who died shortly before moving to the Garden City, the building was designed by the Letchworth architects Parker and Unwin and constructed by Openshaw & Co. The architecture

was based on Edgar Wood's Church of Christ Scientist in Manchester. The building opened in March 1906 at a cost of £1,300, which was collected from fundraising and donations by residents.

The hall has had a variety of uses. In 1906, Mr Arthur Bates started Letchworth's first library at the hall, which initially only contained works by Charles Dickens and Sir Walter Scott. The first Saturday Social in 1906 was here, as was a fancy dress ball in 1907 and even a travelling dentist's surgery. Many local groups have used the hall as their meeting place including the Debating Society, the Vegetarian Society, the Workmen's Club and the Adult School.

In 1907, the Howard Hall Association was created, with a board of twenty elected members, to take legal possession of the hall for use by the public. Also in 1907, an extension, paid for by Juliet Reckitt, provided space for the new Girls' Club where Letchworth girls could meet and learn skills such as dressmaking, cooking and crafts.

Until around 1908 the first Garden City Band and the Letchworth Philharmonic Band rehearsed here. The first Garden City Pantomime was presented at the hall in 1908, where residents performed a satire on Garden City life.

The first Letchworth Parish Council meeting and a number of Letchworth Urban District Council meetings between 1919 and 1924 were held in the hall. In 1921 the building housed the Petty Sessional Court until the courthouse was completed, and in the First World War the Girls' Club extension was used as a synagogue. The building also witnessed meetings addressed by the famous suffragette Mrs Christabel Pankhurst protesting against the Tsar's proposed trip to the country and the early discussions on a licensed public house.

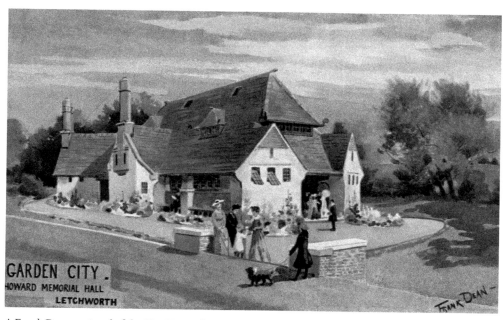

GARDEN CITY .
HOWARD MEMORIAL HALL
LETCHWORTH

A Frank Dean postcard of the Mrs Howard Memorial Hall, c. 1906.

In the 1960s and 1970s the back hall functioned as a youth club known as 'The Leys' which held, among other things, music nights that attracted some of the popular bands of the day.

The hall was renovated and extended between 1998 and 2006 and is now being used by the Letchworth Garden City Community Group.

Howard Park and Gardens

A feature of Parker and Unwin's original town plan, and further apparent in the first 'Development Plan' of 1905, was a large area of planned open space called Howard Park.

Early residents dug a primitive pond, which was popular with intrepid children looking for frogspawn and newts and hosted ice skating in the winter.

At one stage there were suggestions that the pond be filled in, but 1929 plans transformed the pond into a concrete shallow paddling and boating pool. This was hugely popular, particularly during the hot summer of 1932, and remains so to this day. An attractive fountain at the south end, visible in many of the iconic publicity images for which the paddling pool was used, was removed in 1940 following vandalism.

The south end of the park, on the other side of Hillshott, became known as Howard Gardens. In 1922 the area had accommodated the United Services Club, which was constructed out of two large former army dining huts, brought in sections from Minehead, Somerset, and erected with the help of architect Barry Parker. For a short time it doubled up as the Rendezvous Cinema, but the building was demolished in 1929.

A bowling green was built on the empty space, followed by a pavilion and other facilities. The addition of a putting green was part of the wartime 'Holidays at Home' scheme in the 1940s.

The bowling green and its facilities were the catalyst for the development of what is now the Howard Gardens Social and Day Care Centre, which is still fondly referred to as 'the Over 60s Club'. It built in stages between 1951 and 1970.

Further south lies the site of Letchworth Garden City's first swimming pool, the Pixmore Swimming Baths, which were opened in 1907. In 1936, with the baths having been superseded by the O-Zone outdoor swimming pool on Norton Common, the swimming baths were converted to a formal sunken garden named the Ball Memorial Gardens, which was laid out in memory of the former parish, urban district and county councillor Charles F. Ball. The work was paid for by local subscription and carried out by Gavin Jones' Nurseries.

The park and gardens were completely transformed and enhanced in a £1.8-million relandscaping in 2012, which replaced the paddling pool with a more gently undulating pool with numerous fountains and features. The sunken gardens were completely filled in and a bridge was built over the Pix Brook.

The gardens were for a long time the home of Letchworth's only public sculpture, a statue of Sappho, which was sadly stolen in 1998, but happily an excellent reproduction was produced and installed in 2012.

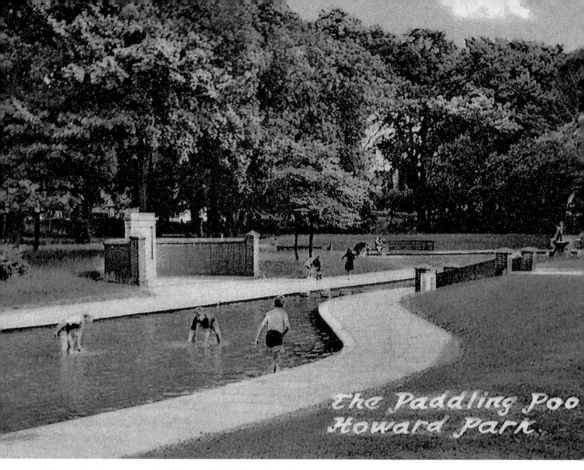

The Paddling Poo
Howard Park

Above: A colour postcard of Howard Park from the 1960s.

Below: The fountain and paddling pool at Howard Park in the 1930s.

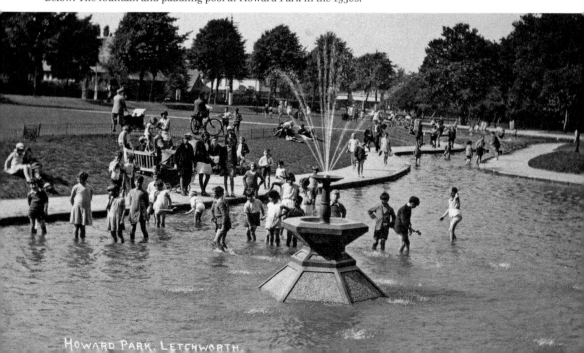

HOWARD PARK, LETCHWORTH.

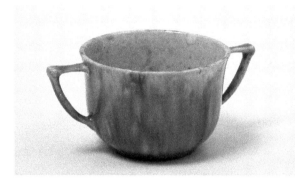

A small two-handled glazed earthenware cup produced in Letchworth at the Iceni Pottery.

Iceni Pottery

An important early Letchworth industry was the Iceni Pottery, which was founded in 1908 by William Harrison Cowlishaw, a keen follower of the Arts and Crafts movement and a supremely talented potter. Iceni Pottery works appear in Arts and Crafts Exhibition Society catalogues in 1910 and 1912, with a variety of items such as earthenware and vases by Cowlishaw costing from 4s to £1 for a bowl. Recognisable characteristics of the pottery include the use of lustre glazes and pierced decoration.

All of the objects made there had a leadless glaze, and were one-off pieces. Much of the work was sold at 'the Crockery Shop', Leys Avenue, which moved to the Colonnade in 1911. Cowlishaw later designed The Cloisters, a fantastical fairy tale castle designed as an open-air school for Annie Lawrence in 1907.

The International Garden Cities Exhibition

The beautiful thatched cottage at No. 296 Norton Way South was erected in 1907 to house the architectural offices of Barry Parker and Raymond Unwin.

It was designed by Barry Parker with the intention that a mirror image would be added to it at a later date to house Raymond Unwin's private studio and drawing office. The extension was never built as Raymond Unwin moved to Hampstead to work on Hampstead Garden Suburb.

The style of the building with its steeply pitched roof thatched with Norfolk reed reflects the architecture of East Anglia, and is based on the form of the Medieval Hall.

The garden was laid out by Parker to imitate the style of Gertrude Jekyll, an architectural gardener of the period whose principles included the introduction of wild plants to natural settings.

In 1937 Parker extended the building by adding a two-storey thatched wing to provide living accommodation for his family.

In 1972 Barry Parker's widow, Mrs Mabel Parker, sold the property to Letchworth Garden City Corporation to be used as a museum. Today the building houses The International Garden Cities Exhibition, a museum and visitor centre celebrating the story of Letchworth Garden City and its legacy worldwide.

Right: Today the building houses a museum and visitor centre celebrating Letchworth and the garden city movement around the world.

Below: The thatched cottage designed by Parker and Unwin as their drawing offices in 1907.

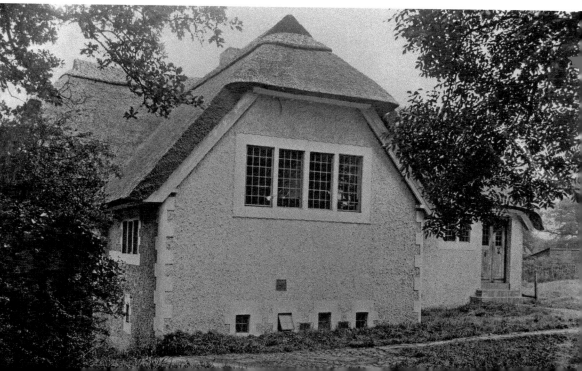

Irvin Airchutes

Leslie Irvin, founder of the Irving Air Chute Co. (as it was officially named due to a typo on his first business card!) was born in America in 1895. He made his first ever parachute jump when he was just fifteen and was one of a group of pioneers in this art of life-saving.

The US company opened its UK branch in Letchworth in 1926, initially to make chutes for the RAF. He came originally to oversee operations and ended up staying over twenty years.

Despite his American citizenship (which meant he could have headed home) he saw the importance of the work that Irving were doing and stayed throughout the wartime austerity.

Thousands of parachutes were produced for the war effort, which saved many lives. So great was the military need that in addition to their main factory on Icknield Way a second factory was opened just before the war and in 1942 they also moved canopy production to the Spirella Factory.

In 1941, Leslie Irvin and two employees, Ivy and Eric Bucknall, spent a year in India instructing on parachute manufacture. These went into immediate use by the Indian Army on the Burma Front. Irvin also returned in 1944 to assist with operations to increase production of chutes in aid of the besieged Allied forces in Imphal. Later, when thanking him for his assistance, the Viceroy of India was to claim that every man in that army owed his life to Leslie Irvin.

Interior of the Irvin Airchutes Factory on Icknield Way.

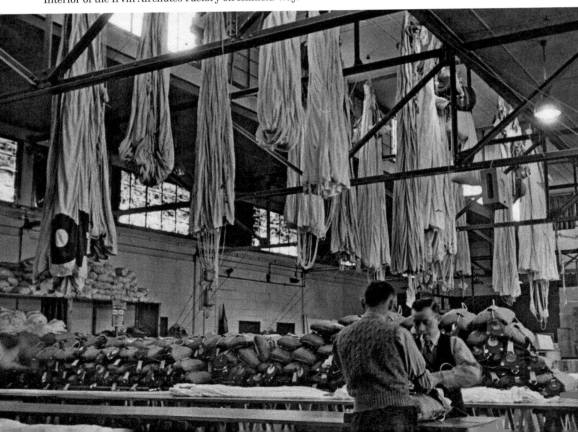

J

John F. Kennedy Gardens

In 1959 the Letchworth Round Table had built a fountain on the Town Square to commemorate their silver jubilee. The Town Square was inexplicably renamed John F. Kennedy Gardens in 1963 in memory of the US President, who had been assassinated that year.

As the gardens matured they became a popular part of the Garden City for several decades, but by the end of the twentieth century they had become tired and overgrown and in need of some attention.

After being granted money from the Heritage Lottery Fund, the North Herts District Council commissioned a dramatic redesign of the gardens to commemorate the town's centenary in 2003.

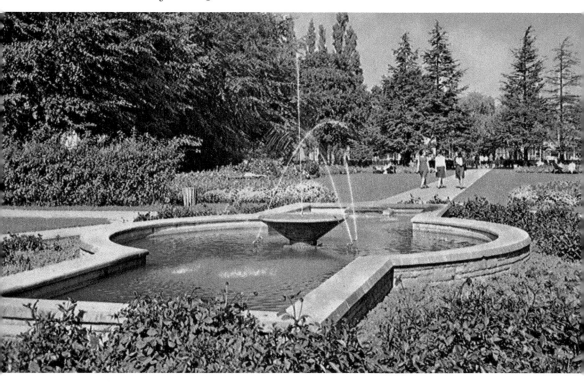

The town square, by then renamed John F. Kennedy Gardens, in the late 1960s.

Kryn and Lahy

Started by Belgian refugees in 1915, Kryn and Lahy were steel founders and engineers for a wide variety of industries, focusing on the locomotive industry. They also produced munitions throughout both the First and Second World Wars. In 1928, the company became part of the 600 Group. One of their most well-known products was the Jones Crane, which became a separate company in 1968. The company was a part of Letchworth Garden City life for sixty-five years and the site was a staggering 27 acres in 1915 and around seven times that size by 1946.

In 1914, Jacques Kryn, a prominent Belgian diamond merchant, fled to England with his brother Georges and Raoul Lahy, both engineers. In 1915 they opened Kryn and Lahy on a site in Icknield Way to manufacture munitions for the war in a factory with a bamboo roof. It was soon realised this site was insufficient and in 1916 a steel foundry was built in Dunhams Lane. Many Belgian refugees came to work at the factory, and there were a mixture of languages spoken. Instructions would be given frequently in French, English and Walloon.

In 1918, the Belgian workers were repatriated and the firm's founders returned to Belgium. Post-war production was hindered by the need to adapt the works for non-munitions production, and the post-war industry boom was missed. Production eventually focused on locomotive castings. However, the 1926 General Strike meant that railway contracts were lost and in 1927 the company entered into voluntary liquidation. In 1928 the company was acquired by George Cohen Sons & Co. Ltd., thus becoming part of the 600 Group but retaining the name Kryn and Lahy (1928) Ltd. Around this time the company also began a subsidiary company, Jones Cranes.

At the outbreak of the Second World War, the company once again began producing munitions for the war effort including 500,000 cast steel bombs, armour piercing and smoke shells, castings for tanks and artillery equipment. Jones Cranes were in great demand by the War Office, and the first cargoes delivered to the Normandy beaches on D-Day were handled by such cranes.

By 1943, the company had changed their name to K. & L. Steelfounders and Engineers Ltd. Many post-war improvements to the factory were made including a 1945 laboratory for analytical testing of steel. Business boomed, and in 1948 output had increased by 30 per cent compared to the previous year despite difficulties in obtaining the materials for production.

By 1960 there were around 1,700 employees, and K. & L. ranked in the top four biggest steelworks in Britain, with a large percentage of work for locomotives,

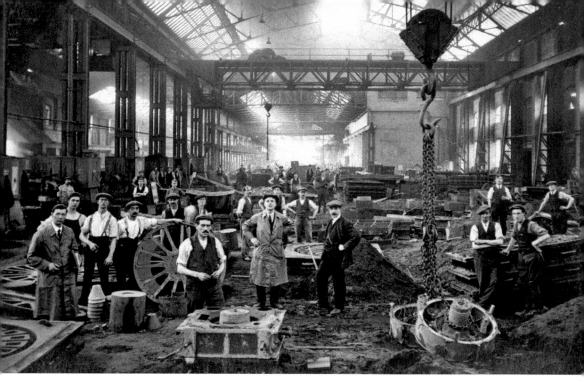

View of the interior of the Kryn & Lahy Steelworks, *c.* 1920s.

earth moving and mechanical handling equipment. In 1962, they opened innovative metallurgical laboratories, which included equipment for using X and Gamma rays for examining castings.

In 1979, along with much of the country's heavy industry, the company was forced to close.

Lawrence, Annie

Annie Lawrence, the second child of Alfred and Mary Elizabeth Lawrence, was born in London in 1863. They were a wealthy and influential family. Through her social work she witnessed the unhealthiness and poverty of the London slums. Determined to resolve the problem she conceived the idea of constructing a building for poor children to grow up in country surroundings with plenty of fresh air. This open-air life would, she believed, help to strengthen their bodies while their minds would be improved by the beauties of nature.

In 1905 she leased a 3-acre plot of land in Letchworth on which to realise her ideal. This took the form of The Cloisters, which was designed by W. H. Cowlishaw. However, while construction was underway her thinking behind its purpose changed. She felt that it would be better if she could teach the teachers and carers of the children as the results would be quicker.

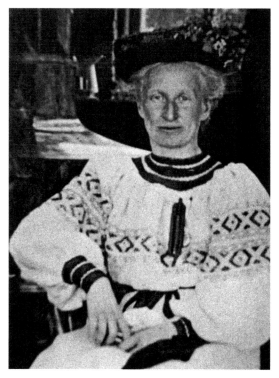

Miss Lawrence pictured seated at an event at The Cloisters.

As one of Letchworth's early pioneers, Miss Lawrence was well known for her characteristic ear trumpet as she was very hard of hearing. She was a strong-willed woman with great generosity and an earnest desire to do good. She was forty-three years old when she came to Letchworth. She lived at Cloisters Lodge, now known as Ladybarn, a house in The Cloisters grounds.

Less known is that she had her own personal belief system, which she called the Dual Day. She claimed that as nature is rhythmical, so too should we be, as without pattern in our life, we will deteriorate. Therefore she believed that we should split days so that morning and afternoon are spent thus: work and play, study and recreation, practical and theoretical work, and material and spiritual.

She died in 1953 aged ninety.

Letchworth Hall

At the centre of the Alington estate, the initial estate identified and purchased for the first garden city, was its manor house, Letchworth Hall, which is now a hotel.

Parts of the building are Jacobean, dating back to at least 1620, with later additions built in the 1840s by its then owner the eccentric Revd John Alington. Having been purchased as part of the estate by the Garden City Pioneer Company in 1903, it was opened as a hotel in 1905 on the same day that the neighbouring golf course also opened.

The building today has had several significant extensions and renovations, but the bulk of the original buildings retain their character and charm. It is still a popular hotel with restaurant and conference facilities.

Colour postcard of Letchworth Hall, *c*. 1960s.

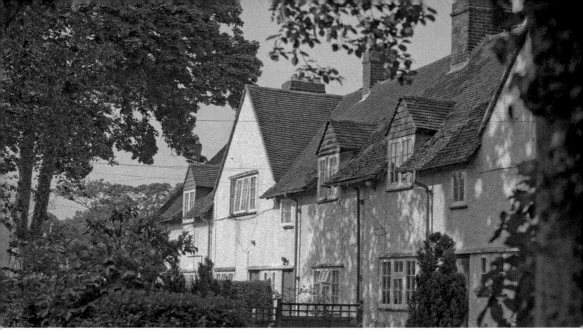

Classic 'Letchworth look' housing on Rushby Walk, one of the country's first cul-de-sacs.

Letchworth Look

In 1904 Parker and Unwin were appointed as consulting architects to the First Garden City Ltd to oversee the designing and building of the first garden city (Parker remained solely in this role from 1914 to 1943).

They each published many articles on design and planning principles and many of their concepts were included in *The Building Regulations*, a small book published in 1905. These guidelines included various factors, from orienting rooms and maximising sunlight at certain times of day to more basic principles covering foundations and sewers, etc.

Their adoption of local vernacular and materials, and their keenness for a more rustic look (applying a roughcast render over the grey local Arlesey white bricks, which they didn't like), led to what became known as a 'Letchworth look'. This choice was partly to differentiate Letchworth homes from average Victorian and Edwardian terraces grey-yellow bricks and slate roofs and also suited the Arts and Crafts style of Parker and Unwin, reminiscent of medieval wattle-and-daub buildings. The aesthetic proved popular and was adopted in garden suburbs all over the UK and continental Europe, from Hampstead to Hellerau.

Furthermore, Letchworth homes would be governed by the need for sunlight and space to grow flowers and vegetables. Houses would be a maximum of twelve per acre. Unwin argued that the increased rent from such spaciousness (twenty per acre was more common) could be offset by residents producing their own food.

Lloyds Lawnmowers

Lloyds & Co. moved from London to their premises at Birds Hill, Letchworth Garden City, in 1915 and they retain a presence at the site to this day. They were originally importers from America but later produced their own goods. They made hand- and motor-propelled lawnmowers, gang mowers, lawn sweepers and sprinklers, electric

L

hedge trimmers, mechanical scythes and various other horticultural implements. The products are renowned for their quality and longevity and have been sold throughout the world to many prestigious clients. The Queen was given a Paladin lawnmower for her silver jubilee, which is still in use today.

In the 1920s the firm had the idea of connecting three mowers together on a towing frame to make a triple gang mower for a horse or tractor draught. There were different specialist lawnmowers from the early days. In the 1930s they introduced the 'Pegasus' lightweight mower for fine turf and, at the same time, the Pennsylvania side-wheel mower for cutting rough grass.

During the Second World War mower production ceased and they made components for the Air Ministry and War Office including over a million mortar shells.

Much of the company's output was intensive machines for large-scale use, e.g. local authorities, racecourses and sports grounds. In the 1950s they supplied the Jockey Club in Newmarket with the world's largest mowing machine (as listed by the *Guinness Book of Records*).

By 1953 Lloyds machines were in use throughout Europe, Canada, Egypt, Australia, India and Argentina, to name but a few. In Malaya, the Lloyds mechanical scythe, the 'Autosickle', was used for cutting down heavy jungle growth. Lloyds' mowers have also been used in some of the world's most renowned golf courses.

Right: The Paladin lawnmower given to Elizabeth II on her silver jubilee in 1977.

Below: The Lloyds Lawnmower factory on Works Road.

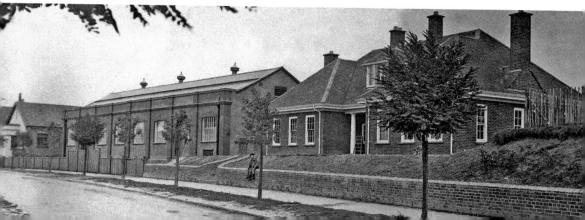

Marmet

Marmet Ltd was founded by Mr E. T. Morris. The company reinvented the baby carriage replacing traditional bar iron chassis with a sprung tubular steel. This resulted in a lighter more movable perambulator.

In 1913 the company moved to Letchworth Garden City where they moved to sheds at the end of Nevells Road that had just been vacated by the Spirella Corset Co. The factory on Icknield Way would not be completed until 1923. Nevertheless, by 1924 production for the US market in particular was so successful that a separate New York company was formed. By 1928 they were making over 100 prams a day.

The company had a reputation for quality and Marmet baby carriages have been used by the royal family including a miniature carriage that was made for Queen Mary's doll's house. They also made nursery furniture, doll's prams and invalid chairs.

In 1949 a subsidiary, Marmet Scotland, was formed and a factory opened in Edinburgh. In 1973 they joined the Restmor Group of Companies, and later closed in 1990.

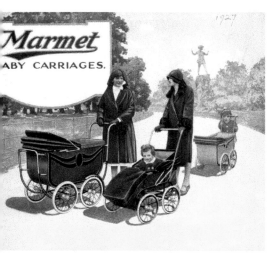

Above left: Advertisement for Marmet Baby Carriages from 1927.

Above right: The royal family at Balmoral, *c.* 1960, with Prince Andrew in a Marmet pram alongside Prince Philip, Elizabeth II, Prince Charles and Princess Anne.

Master Plan

Barry Parker and Raymond Unwin, Arts and Crafts architects from Buxton in Derbyshire, were appointed to draw up the master plan for Letchworth Garden City, incorporating Howard's ideas, which they duly published in 1904. The master plan's semi-formal grid layout was partly influenced by Wren's plan (not realised) for rebuilding the city of London in 1666 after the Great Fire. Further influences can be found at settlements such as Port Sunlight and Bournville and in their own plan for New Earswick, which marginally preceded their Letchworth plan.

The town was clearly defined by different zones of housing (for different classes), shops, civic buildings, parkland and industry. Beyond the town was an agricultural zone – the forerunner of today's green belt concept.

The master plan sought to work with the existing topography and landscaping while utilising the present road network where possible; hence the main routes were derived from the existing Icknield Way and the Hitchin-Baldock Road. These were supplemented by new roads with the main axis, the Broadway, leading to the Town Square (now known as Broadway Gardens), from which a series of roads form a web, as found in many places since. The plan provided employment, public open space and shopping, all of which were walkable. There was a balance of employment and homes, with public sector housing, served by a local centre.

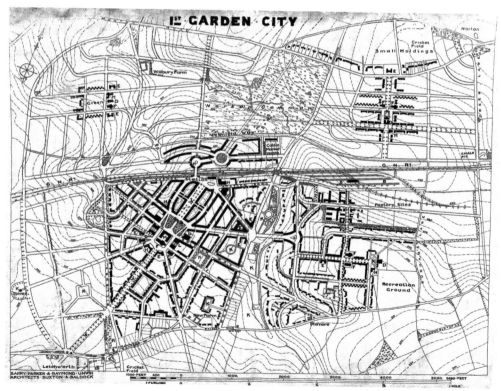

Parker and Unwin's 1904 master plan for Letchworth Garden City.

The extent of the roads was limited in order to ensure better housing and gardens. The layout was dominated by tree-lined routes, gardens, access to open space and the incorporation of allotments and spinneys into the residential areas. Housing was dominated by Arts and Crafts design principles, ensuring high-quality design for all housing types.

The development of Letchworth Garden City quickly demonstrated many of the advantages of the garden city concept. The design of some of the early housing estates by the architects Barry Parker and Raymond Unwin were taken as standard for many similar developments in this country and abroad.

May Day Revels

In Letchworth's early years, processions and festivities were a central part of everyday life. One of the most important of these celebrations was the May Day Revels, an old English folk tradition that the town played a big part in reviving.

One resident recalled, 'As far as I can recall it never rained on May Day, I am sure I am wrong, but May Day to me was always a day of sunshine.' May Day was first celebrated in Letchworth in 1906 and continued as a major part of the town calendar until 1966.

The first May Revels took place near 'The Sheds', a temporary housing area for the newly arrived unemployed, and the site of Letchworth's first elementary school.

Due to the great success of the first event, the celebrations moved between Howard Park and Westholm, and grew to become a May Day Festival. It included arts and crafts exhibitions, musical competitions, a horse and pony display, and a May Fair. In 1910 the scale of the festival grew again and processions of a 'civic, national and "universal" character' made the festival an essential occasion for the whole community.

Nowhere was it more celebrated than at Norton Road School. May Day preparations began with the election of a new queen. Once the queen had been chosen it was time

The Hillshott May Queen ceremony, 1937.

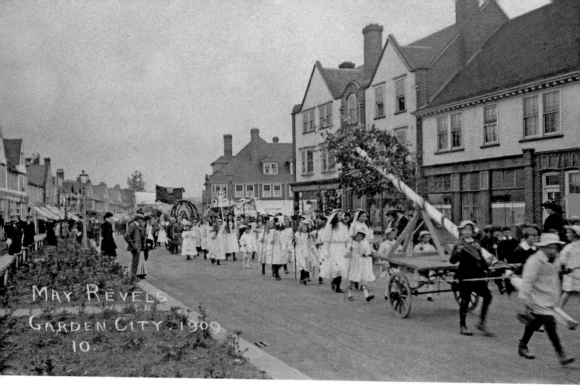

The May Revels maypole in a procession up Leys Avenue, 1909.

for each class to start practising. A maypole would appear in the school hall and children would learn country dances. They wove their bright ribbons in and out, in step, to tunes like 'Nancy's Fancy' and 'John Peel'.

Central to the celebrations was the crowning of the May Queen. A bugle trumpeted starting the event and the retiring queen entered the green followed by her attendants. All dressed as old English characters, the revellers formed a guard of hobby-horses, foresters and Robin Hood's Merry Men. As the queen made her way to the throne, flower maidens danced around and scattered blossoms at her feet.

A second trumpet call heralded the crown bearer, followed by the new queen and her train bearers, pages and attendants, who then paraded gracefully around the green. This done, the new queen knelt to receive her crown from the past queen, who, with a kiss on the forehead, placed the May crown on to her head.

The coronation now over, the two queens danced together before taking their places on their thrones, ready for the revels to begin.

Miss Elspeth McClelland

Among the eighty-five otherwise male entrants to the 1905 Cheap Cottages Exhibition was one woman, Miss Elspeth McClelland. She designed and supervised the building of a cottage in Wilbury Road for the Society of Artists. This group were, in McClelland's own words, 'A Society of Women Decorators who have sometimes felt that architects do not study the requirements from a woman's point of view". Many newspapers ran article's extolling the virtues of what one paper called 'The house that Jill built'.

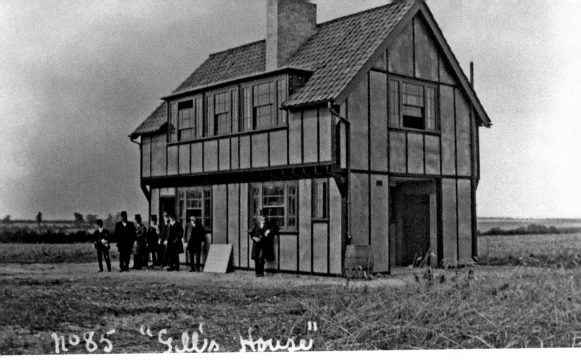

n°85 "Gill's House"

'The House That Gill Built' – Elspeth McLelland's entry into the 1905 Cheap Cottages Exhibition.

Elspeth Cottage was built in concrete with a timber surround in Tudor style but with modern materials. McClelland also designed much of the interior furniture herself in a traditional cottage style.

However, she was keen to point out the cottage was not merely an aesthetic venture, stating that 'Much of the working women's time is spent in the scullery and I am therefore making it a bright and cheerful room with two windows instead of a dismal back kitchen.' The coals and the toilet in this period were usually accessed through an outside door but McClelland placed them inside, again to make life easier for the housewife.

McClelland was also the only woman among 600 male students at the Polytechnic Architecture School in London and was the first woman in the country to practise as an architect.

She was a keen suffragette and her escapade as a 'human letter' was written up by Christabel Pankhurst:

A flash of humour was provided just then, thanks to a Post Office regulation permitting the posting and transmission of human letters. Two suffragettes were duly posted as human letters, at the regulation charge, addressed to the Prime Minister at 10 Downing Street, where, however, acceptance was refused. 'You must be returned: you are dead letters', said Mr Asquith's butler. (1909).

Meadow Way Green

Designed by Courtney M Crickmer and built by the Howard Cottage Society in 1914, this group of houses was a unique co-operative scheme for professional single business women.

Howard Cottage Society houses on Meadow Way Green, 2015.

Midday meals were taken in a communal dining room, with tenants taking turns to purchase food and devise a weekly menu, which was prepared by a cook. In addition, the communal front garden area was communally maintained.

Meredew

Meredew furniture was manufactured in Letchworth for over seventy-five years and was a firm favourite in many homes in the Garden City and far beyond.

Originally established in London in 1879, Meredew moved to Letchworth Garden City in 1914, to new premises in Dunhams Lane, bringing with them a workforce of around fifty families. The proximity to the railway sidings allowed for easy delivery of woods from all over the world. In the 1920s and 1930s, the firm were known for high-quality handmade furniture. Their reputation for quality continued in the second half of the twentieth century, although the furniture's style changed to a much more streamlined modern look.

Although a small firm in the early years, the company prided itself on its wide range. However, this was severely restricted during the Second World War with the advent of utility regulations. During the war Meredew's skilled craftsman built plywood panels for gliders.

In 1945 the company took on its first designer: Alphons Loebenstein. Influenced by the utility range and the new spirit of modernism that gripped the post-war nation, Meredew products took on a radical new modern look. They became a limited company in 1947 and at the same time won many lucrative contracts,

such as cases for Smith's electric clocks and cabinets for Murphy and Bush televisions and radios.

In 1951 the firm employed over 300 people and by the advent of the 1960s it was one of the main furniture manufacturers in the UK. In the mid-1950s they were one of the earliest companies to introduce a flat-pack range. However, they also produced high-grade products for Knoll International such as the design classic the Barcelona chair, which was designed by Mies Van Der Rohe.

In the late 1960s they branched out into kitchen furniture, trading under the name Kandya Meredew. In 1969 they joined Bond Worth Holdings Ltd but this went into receivership in the mid-1970s. Stag Furniture bought Meredew and moved the majority of work to Nottingham where they became Stag Meredew. The Letchworth site wound down in the 1980s and was eventually closed in 1990.

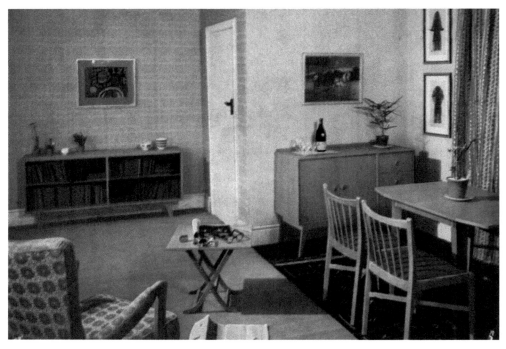

A photograph from a Meredew furniture catalogue, *c.* 1960.

Nook Cottage, No. 2 Cross Street

Nook Cottage was one of the most popular entries in the 1905 Cheap Cottages Exhibition. It was intended for labourers in rural districts. Stress was laid on all the rooms being located on the one floor to simplify the construction and avoid costly scaffolding. The cottage was designed to be durable, fireproof and cost about the same as a timber cottage to build.

The cottage's entry in the exhibition catalogue states:

> Other points to which attention is drawn by the architect are: 'Floors and partitions are absolutely solid, and no unseen spaces below the ceiling where vermin can harbour; avoidance of mouldings that collect dust.... recessed ingle-nook for sitting round the fire, leaving the major portion of the room clear for a table and other furniture'.

Nook Cottage, No. 2 Cross Street, in a *c.* 1905 postcard.

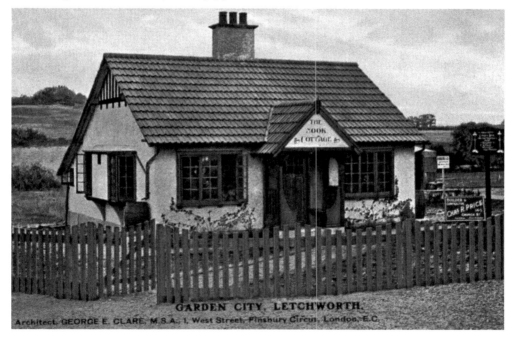

The name of the cottage, while conjuring sentimental notions of bijou cosiness, was a reference to the large inglenook fireplace that dominated the centre of the cottage. A large range straddled both kitchen and living room providing a stove for cooking in the former and heat for the latter. The stove also provided hot water for a bath in the kitchen that was cleverly concealed by a fold-down table when not in use.

One visiting reporter was clearly enamoured with the house:

> I think the best arranged and the prettiest of all the buildings was 'The Nook Cottage,' a marvel of cheapness at £150. The rooms are all on the ground floor, and the kitchen, with its recessed inglenook round the big fireplace, and its box seats to economise space, are reminiscent of the rural homes one finds in real, old-fashioned garden cities, the villages and hamlets of Old England.

Norton Common

From Parker and Unwin's first layout plan to a modern-day map, Norton Common has remained a constant, a huge swathe of green at the heart of the town acting as its 'lung'.

In Ebenezer Howard's plans and drawings he claimed that maintenance of open spaces would be reduced by a large part remaining 'in a state of nature'. Indeed, the common was initially an 'untamed wilderness' looked after by a forester:

> Our favourite place was a tree at Norton Pond and it is still there until this day. All the kids wore the bark off it. We'd play on the tree and get frogspawn out of the pond.
>
> Lucy Williams

A view through the main avenue of trees on Norton Common.

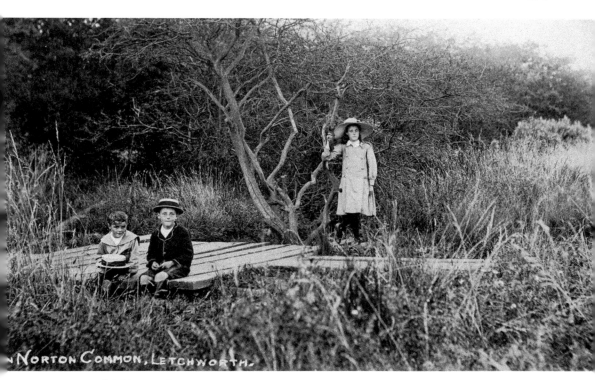

A group of children on the common, *c.* 1912.

In 1922 most of the 70 acres were given over to the Letchworth Urban District Council to maintain as an open space for public use only. Having started out as an 'untamed wilderness', the 1930s saw the common gradually change from being a wildlife refuge to a social hub.

The O-Zone swimming pool was built in 1935, along with tennis courts, a bowling green and other facilities.

The coronation of George VI in 1937 saw the addition of 'Children's Avenues' of trees, each avenue planted by a different local school.

In the same year the common saw the erection of the 'New Coronation Bandstand', given to the town by local businesses. In the 1940s locals enjoyed nothing more than a sunny afternoon on the common listening to the band play. It was unfortunately demolished in 1965 due to persistent vandalism.

Ogle

Ogle is a Letchworth firm that specialises in selling designs and ideas that it can carry through to a prototype model. The company began in 1954 when David Ogle started selling designs from his living room, later progressed to an office in Stevenage, and then in 1960 moved to Birds Hill in Letchworth where a model shop was established in which prototypes could be built. Tragically David Ogle died in a car crash in 1962. However, the company continued and appointed Tom Karen to become managing director and chief designer.

Ogle designed many familiar products. For example, David Ogle designed the bestselling Bush Radio of the 1950s and then Tom Karen repeated the achievement with his iconic radio design of the 1960s. Tom Karen and Ogle also created two icons of 1970s design: the Chopper Bicycle (although this is refuted by Raleigh) and the three-wheeled car the Bond Bug.

The company also designed models for the Y-Fighter and Landspeeder vehicles in the original *Star Wars* films. In the 1980s they pioneered new designs for lorry cabs for British Leyland and designed the Flymo lawnmower and the Cindico folding pushchair. Another much copied design classic was the children's game Marble Run by Kiddicraft, which has its origins in a game that Tom Karen designed

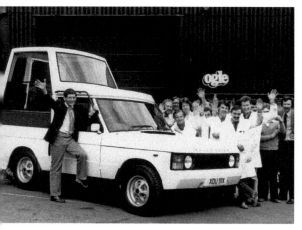

Above left: Tom Karen and Ogle staff pose outside the Letchworth offices with the first Popemobile.

Above right: A collage from 1999 celebrating forty-five years of Ogle Design.

for his children. Last but not least of just a few examples of this company's work is that the branch of Ogle, First Technology, were pioneers in the development of crash test dummies.

Most quirkily perhaps, the company was responsible for the first customised vehicle referred to as the 'Popemobile'.

Olivier, Laurence

One of Britain's most acclaimed actors of the twentieth century, Laurence Olivier spent his childhood years in Letchworth Garden City. Originally from Surrey, Laurence and his family moved to Letchworth in 1919 when his father was appointed rector of St Mary's Church in the hamlet of Old Letchworth. In 1924 Laurence made his acting debut when he was cast as 'Lennox' in the production of *Macbeth* at St Christopher's Theatre, also acting as assistant director in that performance.

From such humble beginnings on the Letchworth stage, he went on to have a glittering acting career, performing professionally 120 times on the stage and achieving fourteen Oscar nominations during his film career.

In 1957 Laurence directed and starred in *The Prince and The Show Girl* with Hollywood icon Marilyn Monroe. The production used corsets produced by Letchworth's own Spirella company to give the Edwardian era costumes an authentic feel.

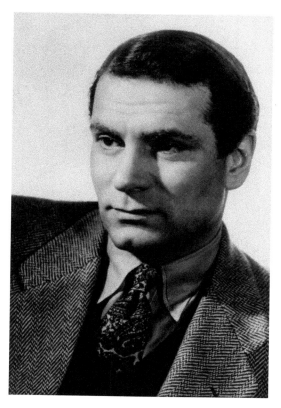

Laurence Olivier, the acclaimed actor who spent his childhood in Letchworth Garden City.

Orwell, George

The journalist and writer George Orwell, author of *Animal Farm* and *Nineteen Eighty-Four*, lived close to Letchworth Garden City between 1936 and 1940. While staying at the village shop in nearby Wallington, Orwell wrote *The Road to Wigan Pier* in 1937 in which he mentioned Letchworth:

> In addition to this there is the horrible--the really disquieting--prevalence of cranks wherever Socialists are gathered together. One sometimes gets the impression that the mere words 'Socialism' and 'Communism' draw towards them with magnetic force every fruit-juice drinker, nudist, sandal-wearer, sex-maniac, Quaker, 'Nature Cure' quack, pacifist, and feminist in England. One day this summer I was riding through Letchworth when the bus stopped and two dreadful-looking old men got on to it. They were both about sixty, both very short, pink, and chubby, and both hatless. One of them was obscenely bald, the other had long grey hair bobbed in the Lloyd George style. They were dressed in pistachio-coloured shirts and khaki shorts into which their huge bottoms were crammed so tightly that you could study every dimple. Their appearance created a mild stir of horror on top of the bus. The man next to me, a commercial traveller I should say, glanced at me, at them, and back again at me, and murmured 'Socialists', as who should say, 'Red Indians'. He was probably right--the I.L.P. were holding their summer school at Letchworth.

Ironically, Orwell almost certainly attended the Independent Labour Party summer school at Letchworth he referred to!

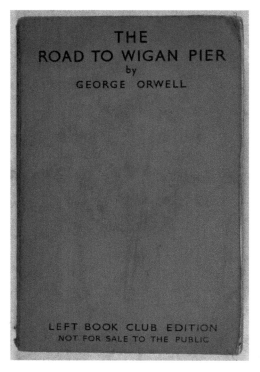

George Orwell lampooned Letchworth and its cranks and socialists in *The Road to Wigan Pier* in 1937.

Palace Cinema

Opened in 1909, the Palace Cinema, or 'Picture Palace', was one of the first purpose-built cinemas in the country. It was designed by Parker and Unwin and was the first building in the Garden City with an electricity supply.

It was purposely located at the then remote top end of Eastcheap to inhibit fire damage should the highly inflammable nitrate film catch fire. As an added precaution, when the town fire station was built not long afterwards in 1911, it was built next door.

The Palace was set up by a local early pioneer of the cinema, Arthur Melbourne-Cooper. He recognised, long before most, the huge role that cinema would play in entertaining the masses. He had started The Alpha company in St Albans in 1906 and also ran a production company, making films to show at his venues.

The building itself was initially quite a plain, almost domestic, design. The frontage incorporated two modest shops but beyond that was a single-level auditorium with seating for 750 people.

In its early years it was regularly used as a venue for popular lectures about natural history and other topics presented by the curator of Letchworth Museum William Percival Westell.

It was extensively refurbished in 1924 with the introduction of balcony seating and most notably a brand new façade in the form of a Hollywood-Roman-style triumphal arch, which wasdesigned by local architect and auctioneer Edgar Simmons. Nonetheless, it was still affectionately known to the locals as the 'flea-pit'!

After the opening of the Broadway Cinema by the Palace's owners in 1936, the older of the two venues took a back seat to its smarter near-neighbour, but there was still enough demand to support both cinemas – initially at least.

In 1955 both cinemas invested in new screens to show films in widescreen CinemaScope, but by the early 1960s the Palace was beginning to decline. In 1961, it diversified its offer by introducing a Sunday bingo night, and also hosted live wrestling. By 1963 the wrestling was a monthly event and one which David Hugill remembers fondly:

> The air was thick with smoke, the noise was so loud it was impossible to think and there were old ladies shouting and using the sort of language best not used in a public place. All to help encourage their favourite contender to win the match. It was great!

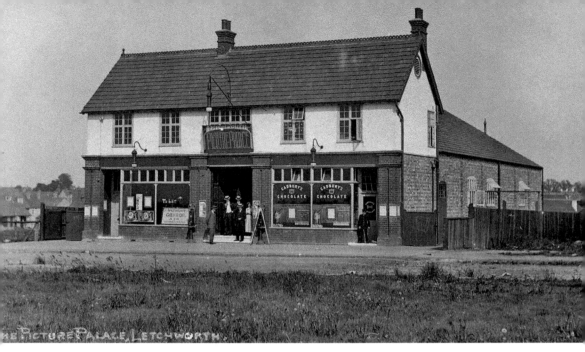

The Picture Palace, *c.* 1909.

The long-neglected building gradually began to show its age. In 1976 the stalls were closed for work downstairs, which was never carried out, and with the cinema lacking a safety certificate for its electrics, it was refused a renewal of its cinematograph license for 1978. It screened its last film and closed, still making an operating profit, on 31 December 1977.

The demise of the Palace caused a major stir in Letchworth and further afield. Many people, including the Garden City Society, called for preservation of the historic auditorium, although it didn't qualify for listing because virtually none of the original 1909 building remained. It lay dormant while its future was argued over, and it stood empty for eight years. Plans were eventually agreed for shops and flats in a pastiche style of Letchworth's pitched roofs and gables. The Palace was finally demolished in 1985.

Pantomime

Although incredibly earnest if asked about their views, the people of Letchworth Garden City seemed capable of laughing at themselves. (Perhaps many of them did not consider themselves to be cranks at all!)

The Garden City Pantomime was written by Garden City residents C. B. Purdom and Charles Lee. The narrator is the 'Spirit of the Place' whose song lampoons Arts and Crafts homes, vegetarians and temperance. These verses are from 'The Song of the Spirit of the Place':

> When the lamps are lit, and the shadows flit, and a balmy breeze from Norway
> Is dodging the screen you've erected between the fireplace and the doorway,
> When the rain and the sleet and the hailstones beat
> through every chink of the casement,

P

And the plaster falls from the mouldy walls, and the
damp wells up from the basement,

Perhaps you reflect that your architect was a bit too Arts-and-Crafty,
And you wish that your lot had been cast in a cot that wasn't quite so draughty.
Ah, then is the hour when you need my power to brace and fortify you,
For draughts and chills bring exquisite thrills when I am hovering by you.

Perhaps you've been out to a midnight rout, and you find,
when you light your candles,
A scavenger's load from the Wilbury Road between your socks and your sandals;
Or again at lunch, as you sit and munch your savoury cabbage fritter,
Your tummy may turn and begin to yearn for a chop and a glass of bitter.

Then you somehow feel that a high ideal is at hing much over-rated,
And you hint to your wife that the Simple Life is a wee bit complicated.
Ah, then is the hour when you need my power to brace and fortify you,
For mud and savoys are constant joys when I am hovering by you.

Above left: The cover of the programme for the 1910 Garden City Pantomime.

Above right: Percy Glossop as 'the spirit of the place'.

69

Parker, Barry

Richard Barry Parker (18 November 1867 – 21 February 1947) was born in Chesterfield, the son of Robert and Fanny Parker. He trained at the Derby School of Art and the studio of George Faulkner Armitage in Altrincham. In 1893 he joined his father in Buxton and designed three large houses for him there.

In 1896 Parker went into partnership with Raymond Unwin, who was Parker's half-cousin, as well as his brother-in-law through marriage to his sister Ethel in 1893. They collaborated on architectural writing including *The Art of Building a Home* (1901), applying the Arts and Crafts movement to working-class housing.

Barry Parker wrote a number of articles for an American publication called *The Craftsman*, whose editor was huge admirer of their work. These articles can be seen as a companion piece to Raymond Unwin's *Town Planning in Practice* (1909) picking up on domestic architecture where Unwin left off on town planning.

In May 1914 the partnership of Parker and Unwin was dissolved, as Unwin became increasingly involved with public sector work.

Barry Parker remained in Letchworth Garden City, becoming the sole consultant architect to First Garden City Ltd (a post in which he remained until 1943). Parker continued his town planning practice, advising on Porto, Portugal, in 1915 and São Paulo, Brazil, in 1917–19.

He also designed a number of public and private buildings in Letchworth Garden City and elsewhere.

In 1927 he was appointed by the city of Manchester to advise on the design of Wythenshawe, a garden suburb for a population of 100,000. Parker was an admirer of the American parkways, notably those in Westchester County, hence the prominence given to Princess Parkway in the Wythenshawe plan.

His presidential address to the Town Planning Institute in 1929 outlined his desire to create parkways in Britain, partly as an answer to the problem of ribbon development on newly built main roads.

His last commission was in 1943, with the layout of an estate in Windsor, Berkshire. He died in 1947.

Oil painting of Barry Parker, unknown artist.

Quakers

Letchworth Friends Meeting House for the Society of Friends, or Quakers, was built in 1907 in South View. It was commissioned by Juliet Reckitt, the daughter of wealthy Hull industrialist Sir James Reckitt of Reckitt Colman mustard fame. (Perhaps his daughter's project in the Garden City inspired him; he began Hull Garden Village in 1908). Its design was based on that of Brigflatts, a seventeenth-century meeting house in Yorkshire, which Juliet, as a Quaker, would have been familiar with.

The name 'Howgills' is from the Howgill Hills that surround Brigflatts, near Sedburgh. It has also been suggested that it was named after a famous Quaker, James Howgill, who also acquired his name from the same hills.

Letchworth Garden City attracted a wide variety of people with different beliefs and ideologies including Quakers, and so a community of Friends was quickly established early in its life. Indeed many of the founders of the garden city movement were Quakers including Joseph Rowntree. Letchworth architects Benjamin Wilson Bidwell and Thomas Geoffry Lucas were also Quakers.

The Letchworth Garden City architects Bennett & Bidwell designed the building, combining the Brigflatts model with key themes of the garden city style. It is believed to be mainly Bidwell's work but it is an excellent example of their work, as it is carefully detailed throughout with excellent joinery.

Copies of Brigflatts' stone-mullioned windows are clearly recognisable from the outside, while the larger gabled entry block has a domestic look with a flat above the ground floor in which Juliet Reckitt resided.

The entrance is marked by a large arch with double doors and an art nouveau-style plaque. The meeting room is at right angles, with its own projecting porch within which are set commemorative foundation stones.

The meeting room is very similar to Brigflatts, featuring simple wooden panelling and a ballustraded gallery above, with the exception being the addition of an Arts and Crafts-style fireplace. One feature it shares with the original is a pen for sheepdogs, although one imagines there was less need for this in Letchworth Garden City than in rural North Yorkshire.

Howgills today is a Grade-II listed building set in a spacious well-kept garden. The meeting house and garden are looked after by wardens who live in the flat once used by Juliet Reckitt.

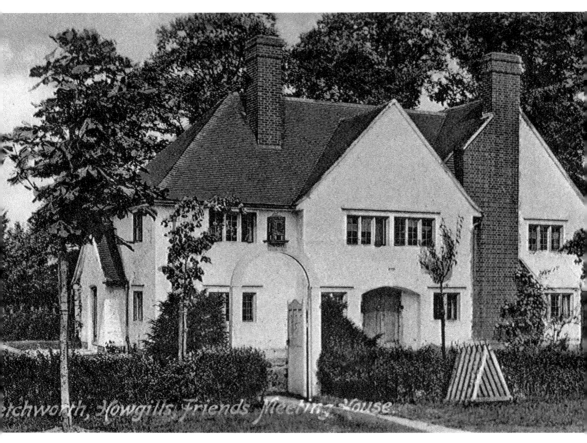

Howgills Society of Friends Meeting House on South View, *c.* 1920.

R

Reckitt, Juliet

Juliet Reckitt was the daughter of George Reckitt of the Hull company Reckitt & Sons, who manufactured starch, laundry blue, metal polish and other cleaning materials. In 1913 the company merged with mustard manufacturers Colman's to become the famous Reckitt and Colman's.

Juliet moved to Letchworth Garden City in its early years and very actively supported the Society of Friends (Quakers). In 1907 she had Howgills in South View built allowing the Society of Friends to hold meetings and lectures there.

The building's design was based on that of Brigflatts, a seventeenth-century meeting house in Yorkshire, which Juliet would have been familiar with. The Letchworth Garden City architects Bennett & Bidwell designed the building, combining the Brigflatts model with key themes of the garden city style.

In 1913 she offered the building as a gift and a deed of transfer was completed. She also helped with finance when the Society of Friends purchased the freehold in 1934. In 1907 she also paid for the Girls' Club extension to Howard Hall.

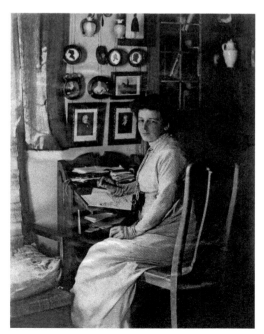

Miss Juliet Reckitt, seated at a desk at Howgills, c. 1910.

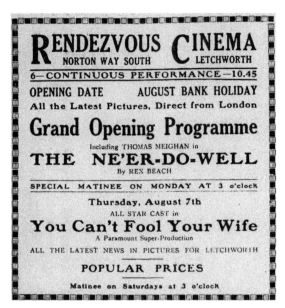

Advertisement for the new Rendezvous Cinema, 1924.

Rendezvous Cinema

In August 1924, with the Palace closed for refurbishments (most notably the addition of its new façade), Letchworth saw the opening of a new cinema.

The Rendezvous opened in the concert hall of the United Services Club. This was primarily a club for ex-servicemen, located on Norton Way South, where the bowling green and Howard Gardens Social Centre are now. It was built in 1922 out of two large army dining huts, which were brought in sections from Hindhead, Surrey, and re-erected with the help of local architect Barry Parker. As well as the concert hall, which had a capacity of 800, there was a billiards room, reading and cards rooms, and a kitchen.

Films began on the August bank holiday Monday in 1924 and thereon normally ran for three days from Mondays and Thursdays. The first film shown was *The Ne'er Do Well* starring Thomas Meighan.

The people of Letchworth had obviously been missing their films because the cinema proved a hit; within weeks the management had to improve and increase the seating.

When the Palace reopened later in 1924, the Rendezvous – which had promoted itself as 'not the biggest, but the best' – seems to have gradually declined. Its last screening was *Passion's Pathway*, starring Estelle Taylor, in April 1927.

Roundabout

One of Letchworth's more quirky claims-to-fame is that it is home to the UK's first roundabout. In the original town plan of Letchworth Garden City drawn up by Barry Parker and Raymond Unwin, there was a point on Broadway where six roads converged. Parker and Unwin drew up a detailed plan of a circular traffic island at this point, 'Sollershott Circus', in July 1908. This was at least partly influenced by the

Sollershott Circus, the UK's first roundabout.

Place d'Etoile in Paris, which Unwin referred to in a 1909 article. The roundabout was unequivocally in use by 1910, so was built '*circa*' (no pun intended!) 1909.

Technically, it didn't actually have a sign saying 'Keep Left' until 1921, and there appears to have been much early confusion from drivers about what exactly to do on encountering this new system.

Rushby Mead

Running for some 2 miles or so, Rushby Mead is populated entirely with the archetypal 'Letchworth look' style of housing, predominantly designed for factory workers and their families. These are mostly today owned (and beautifully maintained) by a local housing association, the Howard Cottage Society, which was founded in 1912.

The road names in Letchworth are often deliberately rustic – Meads, Dales, Hills and Views – an attempt to evoke a romantic rural idyll, far from the squalor and overcrowding of the roads, streets and avenues of some of the towns of Victorian England.

Rushby Mead, *c.* 1930.

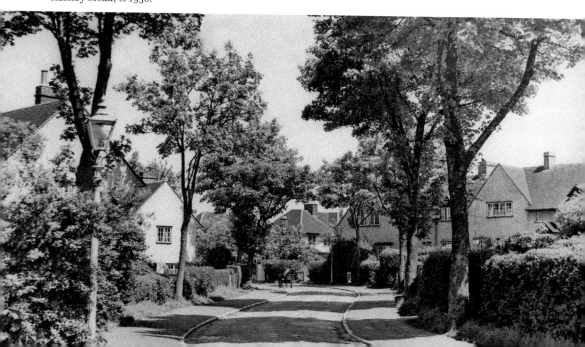

Sappho

For a long time a statue of Sappho was the only public statue in Letchworth Garden City, and a popular and much-loved feature of the town. Sappho was an ancient Greek lyric poet of the seventh century BC.

 The nineteenth-century statue had been presented to the town in 1907 by Isabelle Linnell, the sister of Mrs McLean, the sculptor's widow. It was initially placed in Lytton Avenue, before moving to Meadow Way and Broadwater Avenue. In 1939 it was placed on a concrete plinth in the Ball Memorial Gardens. The statue was stolen in 1998 and a reproduction was made and installed in the redeveloped Howard Gardens.

Sappho, on Broadwater Avenue, 1930s.

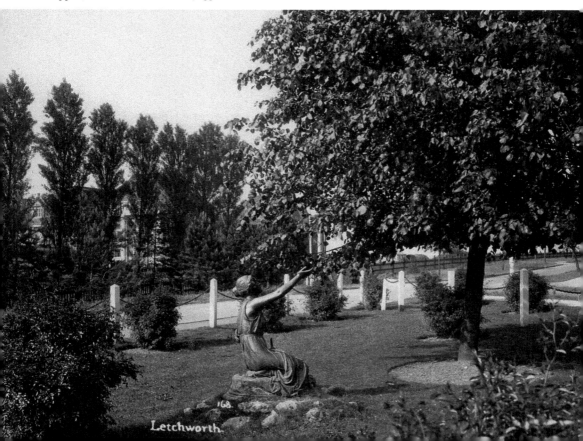

Simple Life

Ingrained in the ethos of the garden city was the concept that people should provide food and nourishment for themselves on their own plots – it was, after all, a garden city.

Ebenezer Howard's vision was to create a harmonious joining of town and country. A garden was about space, freedom and fresh air. Many pioneers who came to Letchworth from the city came for those very values.

One such pioneer was F. G. P. Radclyffe, who came to Letchworth in 1904 from Walthamstow, London and, with the intention of 'getting back to the land', acquired an acre of land at Norton. He decided upon living in a small wooden hut, sleeping in a hammock, which was given up on after just three days in favour of the floor, which often turned to ice from rainwater leaking under the door! For his plot he decided upon the Kropotkin method of deep digging, which consisted of removing the top 12 inches of soil, breaking up the soil underneath for another 12 inches and then replacing the top soil again. Radclyffe wrote: 'This sounds simple enough and the theoretical arguments in its favour are overwhelming until the job is tackled and one learns where the shoe pinches, or, rather, where the back aches.'

This method lasted just one day before it was modified. The determined Radclyffe persevered with his project but ultimately failed, although when asked if it had been worthwhile, he replied,

> The answer to such a question is unhesitatingly, yes, the knowledge of gardening obtained, alone was worth all the capital and trouble expended. But the effect on one's outlook in life and the general experience gained is beyond question of great value.

Many people grew fruit and vegetables and kept ducks, chickens and even pigs. In fact, in 1922 it was proposed to the council that a ban would be made on all cockerels, such was the extent of the din from their crowing in the morning. Neighbours often bartered goods. Some simple-lifers embraced the notion of the untamed countryside and would cultivate weeds in their wilderness gardens.

The Simple Lifer's self-sufficient garden –
Mr Baker and his ducks on Nevells Road.

Skittles Inn (now The Settlement)

The Skittles Inn (1907–23)

Opened on 8 March 1907, the Skittles Inn was the famous 'pub with no beer'. Named after the skittles alley in a room at the side, the building was designed by Parker and Unwin to combine the styles of an old English inn and a continental café. Its landlord was the well-known W. G. Furmston, known to many as 'Old Bill'.

The Skittles Inn was built 'to supply meals, literature, rest and social intercourse, principally for working people.' The skittles alley, from which the building got its name, was rather short-lived, and was soon replaced by a gymnasium and then converted into meeting rooms. Many societies used these rooms, and they were used for significant events including strike meetings. Although not licensed for the sale of alcohol, the Skittles was licensed for billiards and tobacco.

Meals were sold from 6 a.m. to 10 p.m. at a cost of 6*d* upwards. Drink variety was not lost. There were around fifty types of drink available including apple wine, sarsaparilla and cocoa. A temperance cider was sold but was then banned by excise, who claimed it had above the 2 per cent alcohol allowed. Bill Furmston had his suspicions about the alcohol content of a 'Nut-brown barley beer', which according to one customer looked like beer, smelt like beer, tasted like beer and 'titillated the nerves to the point of exhilaration'. He banned said brew but later reinstated it.

An oil painting of the Skittles Inn by Letchworth artist C. J. Fox.

It was said that 'all roads lead to the Skittles'. However, in 1913 the railway bridge in Norton Way North opened, which meant that major traffic bypassed the Skittles. Trade dwindled as a result and in 1923 the establishment closed.

The Settlement

The Settlement, which still plays an active part in Letchworth Garden City, was founded in 1920 by members of Howgills as an adult education school. In 1925 The Settlement bought the building that had once been the Skittles Inn for £2,000. Barry Parker was chairman and remained so until 1944.

Various courses have been run at The Settlement and many clubs are affiliated. Courses in 1926 included languages, history, science and folk dancing. These were held in The Settlement building and also taken out to local villages. Today it continues to be a place for adult education offering a variety of courses, from cake decorating to philosophy, has ninety groups and is used by a further twenty-five organisations as a meeting place.

Spirella

Spirella was an American company that revolutionised the manufacture of corsets by inventing a new type of stay from sprung aluminium, which one could twist, turn and tie a knot in. The stay is the boning element that gives a corset its structure and shape. Previously they had been made of either brittle whalebone or rigid steel, either of which could break and cause pain or embarrassment.

The company sought to expand across the Atlantic and chose Letchworth Garden City because they shared their utopian ideals. Spirella was light years

Spirella, 'the factory of beauty', set in its beautiful gardens, *c.* 1930.

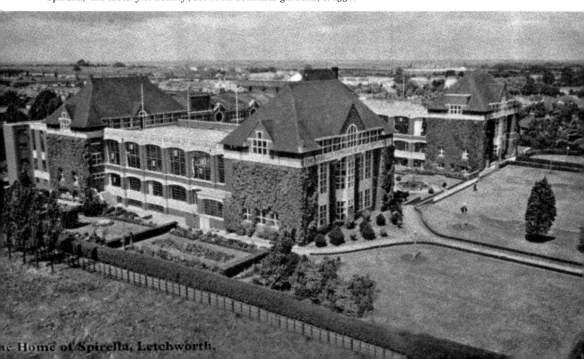

e Home of Spirella, Letchworth.

ahead of most industries in its provision for its workforce. Its motto 'Healthy Happy Workers are the World's Best' ensured that the staff at the smart new factory – built in three stages between 1912 and 1920 to a design by Cecil Hignett – were well looked after. There were medical staff on site, a lending library, a bicycle repair man and a hot bath once a week on company time. Many of the (largely female) employees stayed there their entire working lives. Spirella corsets were a high-quality item, bespoke for each client, with measurements taken in the customer's home by qualified 'corsetieres' and then the orders made up in the factory at Letchworth, before being dispatched.

Sadly the company declined in the 1970s as fashions changed, and the Grade II*-listed building became in need of some attention. In the mid-1990s it was purchased and transformed by Letchworth Garden City Heritage Foundation, who turned it into high-tech offices in an £11-million regeneration.

St Edmundsbury Weaving Works

The St Edmundsbury Weaving Works was established by Edmund Hunter in 1902 in Haslemere, Surrey. The company was already a success when the Hunters moved to Letchworth Garden City in 1908, having frequently exhibited and won awards. Working with architects Barry Parker and Raymond Unwin, the Hunters built their home, St Brigid's, in Sollershott West, and their factory in Ridge Road. Both buildings remain today.

The Hunters were enthusiastic members of the Garden City community, particularly in musical and theatrical groups. Alec Hunter, Edmund's son, was the founder of the Letchworth Morris Dancers. Edmund Hunter was favourably known for his treatment of employees, providing good working conditions and allowing workers paid holiday.

The company produced woven textiles, mostly in silk, for private and ecclesiastical clients. The original aim of St Edmundsbury was to produce textiles on a handloom, reflecting the pro-handicraft attitudes of the Arts and Crafts movement. The early textiles at the factory were produced in this way, but later work for clients such as Burberry used power looms to fulfil the needs of the commercial market. Throughout the history of the company, St Edmundsbury produced work for prominent clients including St Paul's Cathedral, Westminster Abbey, Buckingham Palace and Windsor Castle. They also designed some textiles for Liberty of London.

The company made a wide range of textiles including altar hangings, church vestments, upholstery fabrics, tablecloths, silk scarves and book covers. The designs of the textiles were generally quite intricate and high quality. The textiles were primarily designed by Edmund Hunter, although Alec Hunter also contributed in his time at the firm from 1919 to 1927. The firm's early style was mainly Arts and Crafts, and they regularly exhibited at the Arts & Crafts Society exhibitions. The subject matter of the designs reflected Edmund's personal interests – heraldry, theosophy, dancing, animals, nature and tarot cards – with Alec's designs, which often featured ships and Morris dancers. Religious images appeared regularly since a number of textiles were designed for churches. The designs became more geometric and stylised in the late 1920s following the art deco movement.

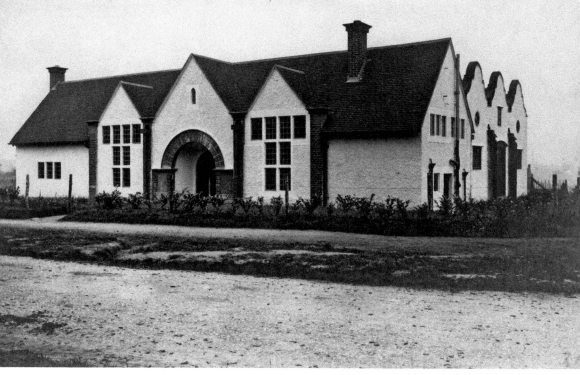

The St Edmundsbury Weaving Works factory designed by Parker and Unwin in 1908.

Another significant textile designed by Edmund Hunter and produced by the weaving works was the Garden City banner used in early Letchworth parades and festivals, and seen in a number of early photographs. The banner bore symbolism for the hopes of the new town.

In the late 1920s the company worked with Morton Sundour Fabrics of Carlisle, establishing the Edinburgh Weavers, where they were able to produce their designs on a much larger scale. However, the working relationship only lasted into the early 1930s. Sadly, in this period, the Letchworth factory slowly stopped manufacture. Alec Hunter continued to practice as a textile designer, working for companies such as Warners in Braintree. Edmund Hunter retired to Hampstead Garden Suburb.

The St Edmundsbury Weaving Works building was later used by the St Christopher Press.

St Francis' College

St Francis' College was opened in 1933 by a group of Sisters of Charity of Jesus and Mary from Ghent, Belgium. Before the Sisters bought the college building on Broadway, it had been used by St Christopher School until 1928. The new college was dedicated to St Francis de Sales, the patron saint of Cardinal Francis Bourne, the Archbishop of Westminster, who had helped the Sisters set up the college.

When the school first opened it had just twenty-nine pupils but by the end of the 1930s it had over 200 and more space was needed. The sisters built a new building overlooking Broadway containing domestic rooms such as kitchens, dining rooms and dormitories.

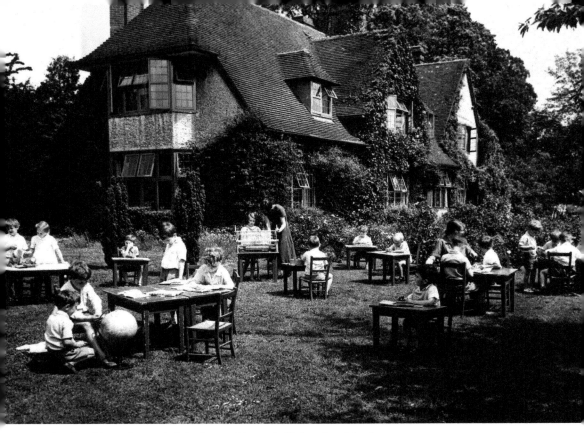

Pupils taking a class outisde in the sunshine at St Christopher School.

St Francis' College on Broadway, *c.* 1950.

In 1948 the college also began to train English-speaking sisters to work in schools and hospitals across the world.

In 1983, the school's fiftieth anniversary, the Sisters of Charity of Jesus and Mary decided to close the college. Distressed parents and staff created an educational charity, the St Francis' College Trust, to take over the running of the college.

The college is now a multi-denominational Christian community that welcomes pupils of all faiths.

St Mary's Church, Old Letchworth

The Church of St Mary the Virgin, in the original hamlet of Old Letchworth, dates from at least the late twelfth century, although it existed in some form as early as the Domesday Book in 1086. Indeed, building material found in the churchyard suggests that there may have been an earlier Saxon structure on the site. The porch was added during the fifteenth century and the belfry in around 1500 (housing a much older bell). The diminutive size of the church – it is just 60 feet long – reflects the remoteness and small size of Letchworth Manor. It remained the parish church for Old Letchworth until 1967 when St Michael's was built on Broadway.

Among its notable internal features, the church contains a small recumbent effigy of the crusader knight Sir Richard de Mountfitchet. His heart is reputed to have been buried beneath the church. The building has changed very little over the centuries and retains a quiet charm today.

The Church of St Mary the Virgin in Old Letchworth, *c.* 2015.

The Three Magnets

Perhaps one of Howard's finest skills was his ability to convey his ideas so effectively with diagrams. His 1898 book *To-Morrow: A Peaceful Path to Real Reform*, which set out his ideas for Garden Cities, featured this illustration, 'The Three Magnets'. It perfectly illustrates Howard's combination of the best parts of both town and country in the third alternative, 'town-country'. The people, he illustrated, would be attracted to the Garden City like iron filings to a magnet.

Howard's 'three magnets' diagram illustrated his vision for what he called 'a third alternative':

> There are in reality not only ... two alternatives - town life and country life - but a third alternative, in which all the advantages of the most energetic and active town life, with all the beauty and delight of the country, may be secured in perfect combination.
>
> Town and country must be married, and out of this joyous union will spring a new hope, a new life, a new civilization.

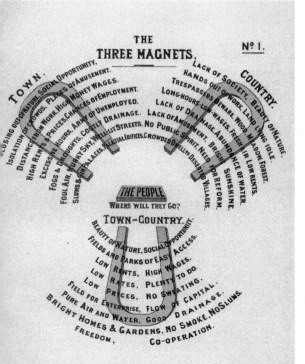

Howard's iconic 'Three Magnets' diagram, published in his 1898 book *To-Morrow: A Peaceful Path to Real Reform*.

Tree-lined Streets

Immediately after purchasing the estate, the First Garden City Ltd commenced a programme of tree planting. In 1905 the Worshipful Company of Gardeners visited Letchworth and expressed their approval of all the tree planting that had been done. By 1909 an estimated 100,000 trees were claimed to have been planted.

For every road in Letchworth there were different species, some native, such as oak, elm and horse chestnut, and others more exotic, such as the Locust trees planted along Hillshott or the Stags Horn Sumachs from North America planted along South View. Station Road and Leys Avenue had flower beds where we now have parked cars.

Old photographs show the baby trees that must have reminded citizens how new the town was. By the Second World War the tree-lined streets of Letchworth were well established and helped to camouflage the town and its important war production from German aircraft.

> The roadways are much narrower than in other towns, but the trees and greenswards and the distance between the houses make the streets a continuous open space, to which occasional shrubberies and beds of flowers give additional variety. Each street has a slightly different character, so that you may walk the whole round of the town and think yourself to be in a garden all the while.
>
> C. B. Purdom, *The Garden City*, 1913

Icknield Way, Letchworth, in Almond Blossom Time

LETCHWORTH

Where Town and Country meet

128 PAGES PRICE SIXPENCE

Icknield Way in Almond Blossom featured on the front of this 1930 publication.

Unwin, Raymond

Raymond Unwin (1863–1940) was born in Rotherham, Yorkshire, and grew up in Oxford after his father sold up his business and moved there to study. He was educated at Magdalen College School, Oxford. In 1884 he returned to the North to become an apprentice engineer for Stavely Iron & Coal Co. near Chesterfield.

Unwin had become interested in social issues at an early age and was inspired by the lectures and ideals of John Ruskin and William Morris. In 1885 he moved to Manchester and became secretary of Morris's local Socialist League. He also became a close friend of the socialist philosopher Edward Carpenter, whose utopian community ideas led to his developing a small commune at Millthorpe near Sheffield.

In 1887 he returned to Staveley Iron as an engineer, working on development of mining townships and various other buildings, which taught him the basic skills of land assembly, surveying and building development.

In 1893 he married Barry Parker's sister Ethel, and he and Parker formed a partnership in 1896 based in Buxton, Derbyshire. They preferred the simple vernacular style and made it their aim to improve housing standards for the working classes.

After several years of private commissions, in 1902 Parker and Unwin were asked to design a model village at New Earswick near York for Joseph and Benjamin Seebohm Rowntree, which proved to be a useful test bed for many of the schemes at Letchworth.

After their master plan for Letchworth was adopted in 1904 they opened a second office at Baldock, eventually opening the architectural office in this building in 1907.

In 1905 Henrietta Barnett asked them to plan the new garden suburb at Hampstead, and in 1906 Unwin moved from Letchworth to Hampstead, and he lived here for the rest of his life at the farmstead 'Wyldes'.

In 1912 Unwin published his influential book *Nothing Gained by Overcrowding*, which made both the aesthetic and the economic argument for how better homes could be built along garden city lines than traditional terraced back-to-backs.

Unwin joined the Local Government Board in December 1914 and was seconded to the Ministry of Munitions shortly afterwards to design the villages of Gretna and Eastriggs and supervise others. From 1917 he had an influential role at the Tudor Walters Committee, whose report was published in 1919, the year in which he was appointed chief architect to the newly formed Ministry of Health.

His demonstration during the First World War of the principles of building homes rapidly and economically while maintaining satisfactory standards for gardens,

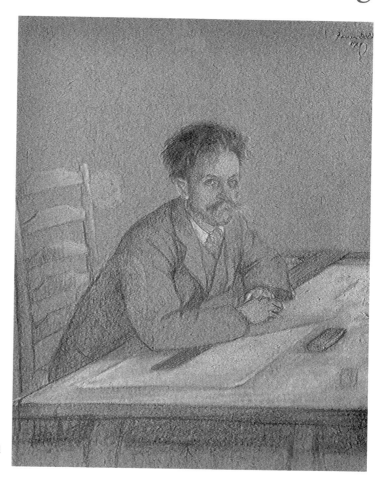

Pastel portrait of Raymond
Unwin by Frances Dodd.

family privacy and internal spaces gave him great influence over the Tudor Walters
Committee on working-class housing, and thus, indirectly, over much interwar public
housing. It has been argued that Unwin, through the influence he exerted on council
housing design, may have had a direct influence on as many as 1.2 million homes in
the UK.

After a productive retirement on both sides of the Atlantic, Raymond Unwin died at
his daughter's summer home in Lyme, Connecticut, on 29 June 1940.

Vegetarians

Many early residents of Letchworth were attracted by its utopian vision; they saw it as a chance to create a new society. Therefore people with a broad range of philosophies came here including a number of vegetarians or 'cranks'.

Cranks was (and to some extent remains) a popular slang term used for vegetarians and is defined in the dictionary as 'an eccentric person especially one obsessed by a particular theory'. This emerged because of a growing awareness in society of animal welfare and the search for alternative healthy lifestyles. However, vegetarianism

A vegetarian supper, probably Letchworth Vegetarian Society, at the People's House, Letchworth, *c.* 1930.

has existed for thousands of years, from Brahmanism and Buddhism in the East to famous vegetarians from the classical world such as Pythagoras and Socrates.

From as early as 1907 Letchworth Garden City had a vegetarian store, the Simple Life Hotel and Food Reform Store and Restaurant, at No. 9 Leys Avenue. The store was run by Mr Alfred T. Crouch and his family. In addition to managing his business, Mr Crouch was also the first president of the Chamber of Commerce and Social Captain for the Vegetarian Cycling Club.

Mr Crouch's wife was the secretary of the Health Culture Society. This society was formed in 1907 'for the promotion of Food Reform (Fleshless Diet), Dress Reform and Physical Culture'. The society published a regular column, 'Health Culture Notes' in *The Citizen*, the local newspaper. In July 1907, the column commented on the recipe for long life according to a Parisian scientist: 'Simple but sufficient food, mostly vegetarian', no alcohol or tobacco, and to 'carefully avoid any form of "excitement" throughout their life'.

When the Crouch family left for Tasmania in 1913, Moss & Sons grocers opened a health food store, also in Leys Avenue, and later Mr Hayward opened The Radnage Agency in The Arcade.

After the Health Culture Society ended in 1909, there was nothing similar until the formation of the Letchworth Health Society in around 1927, presided over by Mrs Ironside. This society continued until 1947 when it became the Letchworth Vegetarian Society, which continues to this day.

Wallace, Revd Bruce

Born in 1854, Bruce Wallace was the son of Revd James Wallace, a pioneer missionary in India. Educated in Scotland, Switzerland and Belfast, he devoted himself to social work from an early age.

Wallace was a member of the Protestant reformed church movements, before establishing the Brotherhood Church in London, to which he ministered and edited the *Brotherhood Journal*. He was also one of the founders of the Fabian Society.

His interest in land ownership put him in into contact with Ebenezer Howard and he was a founding member of the Garden City Association. One of Letchworth's earliest residents, he lived in the Quadrant and held a religious gathering every Sunday evening at Howard Hall. In 1905 he founded the Alpha Union, and many of this spiritual group's conferences were held at The Cloisters. He resided in a simple fashion and lived on a diet of wholemeal bread and fruit.

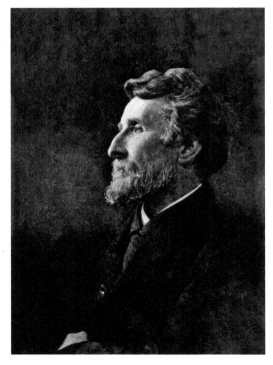

Coloured photographic portrait of Revd Bruce Wallace, *c.* 1907.

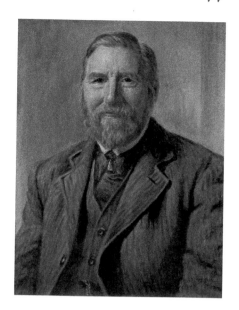

Oil portrait of William Webb by F. S. Ogilvie.

William Webb

Having retired from the Metropolitan Police force, William Webb was inspired to come to the Garden City after hearing an Ebenezer Howard lecture and moved with his family to Letchworth in 1905. As one of the town's early pioneers he was involved in funding the Free Church, was one of the earliest Letchworth Co-operative movement supporters and was a keen horticulturist. He was the author of *Garden First in Land Development* published in 1920.

Wilbury Road, No. 158

This Grade II-listed cottage is one of the world's earliest prefabricated buildings, and is unique in Letchworth Garden City.

The walls were made of concrete panels using clinker aggregate reinforced with steel, and were constructed at Cobbs Quarry in Liverpool. Then each wall was transported to Letchworth by rail. The house was then assembled on site, fitting together like a 3-D jigsaw puzzle. Once all the parts were on site, the house took just thirty-six hours to put together.

It was economical due to its utilisation of waste materials (clinker), small amount of labour and speed of build. Expensive woodwork was replaced by moulded concrete wherever possible, right down to the doors and windows being fixed directly onto the concrete. The building was designed to have a long life and a small cost of upkeep and insurance.

As with many of the Cheap Cottages, the system was most economical when many identical buildings were constructed at once, as many of the elements could be reproduced by repetitive methods. Indeed, this innovative system of building construction was devised specifically to provide large numbers of sanitary and economical homes for the labouring classes in Liverpool. Sadly this never happened.

No. 158 Wilbury Road, one of the world's first prefabricated houses.

Wing, Edgar

Born in Australia, Edgar Wing moved to Letchworth Garden City in 1906, and a year later founded the Guild of Help, an organisation that supported the relief of poverty and distress. He played a very active role in all early Letchworth life as a writer for *The Letchworth Magazine*, a supporter of First Garden City Residents Share Purchase Society and a member of the Residents Union. He died in August 1929.

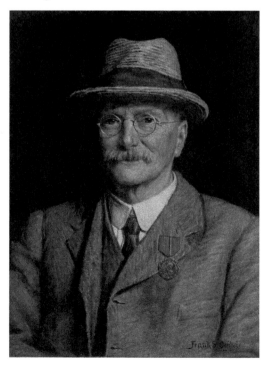

Oil portrait of Edgar Wing by F. S. Ogilvie.

X

'X' Marks the Spot

When Barry Parker and Raymond Unwin were surveying the estate that would become Letchworth Garden City, they were keen to incorporate existing features and hedgerows. They oriented the centre of the layout plan around three mature oak trees on a field that would become the main square (now Broadway Gardens).

The trees are clearly mapped on Parker and Unwin's proposed layout for the central square, drawn up in 1913, but which never happened.

Sadly one of the trees later became diseased and had to be cut down, but two of the three still survive to this day.

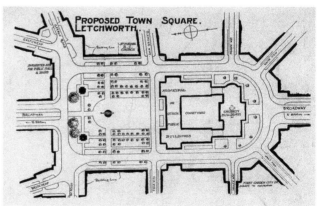

Proposed layout for central square, with the three oaks clearly indicated.

The three trees on main square in 1910.

Young's Pinello

Young's Pinello is Letchworth Garden City's very own apple variety. It was developed in the 1930s by Letchworth resident Eva Young. A Young's Pinello tree is in the front garden at The International Garden Cities Exhibition. The fruit produced is a medium-sized pale yellow-skinned apple with a scarlet flush and stripes. It has firm, aromatic, sweet-tasting flesh.

A. W. Brunt, in *A Pageant of Letchworth*, described Miss Young as follows:

> Miss Eva L. Young was a loyal Garden Citizen. On her retirement from a strenuous life as an educationalist she came to 'Pine Tree Lodge,' Icknield Way, in the very early days and was a genial and helpful presence until her decease on December 14th, 1939. Education, philosophy, horticulture and Esperanto were her chief interests. To the first she contributed a series of books under the title "The Happy Reader" to the second her last and ripest literary expression, 'A Philosophy of Reality'. She induced her brother, Dalhousie, to help her to set a number of songs in Esperanto, and wrote several herself. During the last war she purchased a house as a creche for mothers engaged in war-time employment.

Above: Young's Pinello, Letchworth's variety of apple.

Left: A Young's Pinello tree growing in the garden at The International Garden Cities Exhibition.

Z

Zeppelin

Late on the night of the 1 October 1916 the First World War really arrived in this corner of North Hertfordshire. At 1.14 in the morning a German Zeppelin bomber dropped over fifty bombs on Hitchin and on the village of Willian, on the south of the Letchworth Garden City estate. Although there was surprisingly little damage done, tragically one man was killed in the raid.

On the next night, Letchworth people witnessed a further encounter as a Zeppelin on fire in mid-air was seen to the south east of the town and finally crashed in Cuffley, near Enfield, creating a sheet of light in the sky that could be seen for many miles around. Many Letchworth people visited the scene.

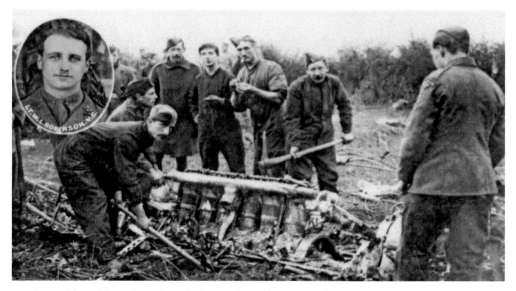

Members of the public picking through the wreckage of the crashed Zeppelin that fell on Cuffley.

Acknowledgements

I am indebted to the invaluable and friendly help in picture research, editing and proofreading by my colleague Sophie Walter, as well as significant and useful editorial assistance from David Ames.

The content of this book is the result of many years dedicated to exploring the history of this unique town. It would be remiss of me not to thank the helpful assistance of numerous museum colleagues over the course of the last fifteen years that I've been fortunate enough to spend time working within Letchworth Garden City, namely Vicky Axell, Lindsay Duncan, Aimee Flack, Lucy Laing, Robert Lancaster, Gemma Leader, Beth McDougall, Eleanor Sier and Katie Weston.

It's a privilege to spend one's working life learning about and telling the story of a place, and I'm delighted to be able to share a little of that here in this book. I hope you enjoy reading it as much as I (and my colleagues) have enjoyed putting it together.

About the Author

Josh Tidy is the Curator at The International Garden Cities Exhibition, a museum and visitor centre funded and run by Letchworth Garden City Heritage Foundation. He has a keen knowledge of the history of Letchworth and the garden city movement and is a passionate advocate for garden cities, past and present, across the world. He has appeared on several programmes on BBC radio and television, including *Celebrity Antiques Road Trip* and *Great British Train Journeys with Michael Portillo*. Josh is also the author of several other books about Letchworth (including *Letchworth Garden City Through Time* for Amberley) and has been celebrating and sharing this special town's unique history since its centenary in 2003.